# take heart

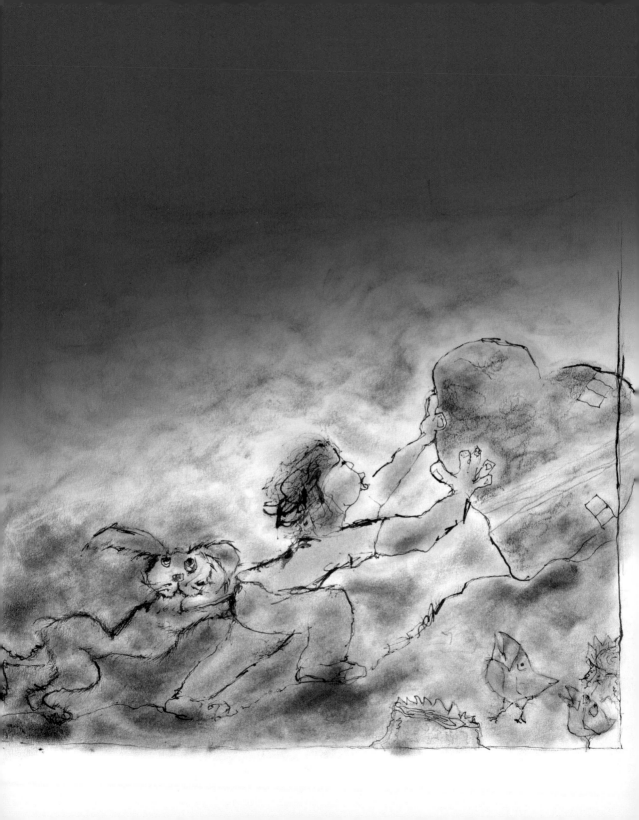

# take heart

## ENCOURAGEMENT *for* EARTH'S WEARY LOVERS

ESSAYS BY Kathleen Dean Moore    ART BY Bob Haverluck

Oregon State University Press ❋ *Corvallis*

Cataloging-in-publication data is available
from the Library of Congress.

♾ This paper meets the requirements of ANSI/NISO Z39.48-1992
(Permanence of Paper).

**Oregon State University**
**OSU Press**

Oregon State University Press
121 The Valley Library
Corvallis OR 97331-4501
541-737-3166 • fax 541-737-3170
www.osupress.oregonstate.edu

# contents

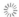

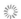

# preface    *Kathleen Dean Moore and Bob Haverluck*

Day after day, people stand bravely for environmental justice and the sustaining beauty of ongoing life, summoning all the strength of their beating hearts to defend what they love—singing birds and rivers, healthy neighborhoods, ancient forests, frogs, decent work, small children, even the future itself. The resilient life-urgency of the Earth is their strong ally. Even so, it's hard work to defend ongoing life against all the power of Bigger and More—and Earth's lovers are weary.

Our hearts have so often been broken. So often have they been patched and thumped and pumped up again. It's sometimes hard to go on.

But this continues to be the work of our battered hearts: To celebrate the sweet singing pond, even as dozers fill it with construction debris. To hold children in our strong arms, even as we know their future grows more uncertain with every methane flare. To resist the poisons that seep into neighborhoods, bodies, and politics. To sing praises to creation, even as the seas themselves invade the dry land, sloshing starved puffins into the tide wrack and driving people from their homes. Frantically to ask what can be done, even as entire forests call out in the languages of fire and beetle-kill. To rejoice in the beauty of the blue planet, scarred now, singed and torn, even as we grieve its losses. To stand together for justice and joyful thriving.

It is easy to become disheartened. But it is impossible to quit.

So. What can this little book offer the planet's defenders? We bring heartening. *Hearten*, verb, *to increase confidence, to encourage*; the ongoing repair and maintenance of the soft machinery of the heart. We invite people to take heart.

Taking heart is not hope exactly, but maybe it's courage. Not reassurance exactly, but reason to persevere. Not the promise of good results—it does not depend on winning odds—but a call to integrity. Not solutions to the planetary crisis, but some modest advice for the inevitable crisis of the heart. Not victory over injustice, but at least recognition of its cruel ubiquity. Not heroism, but membership in a community of caring. Not strength—we can't offer that—but stubbornness, which might be just as good. Not good cheer entirely, but a chance to chuckle; and gladness to be part of the strange and necessary work for the endangered Earth.

Given the ease of destruction and the difficulty of restoration, the work of defending planetary thriving will not end. It's not like carving a lion from a rock. As activists know, it's more like pushing the rock up a mountain every single day, only to watch it bounce down again. The gratification of the work is not, therefore, in the accomplishment, the stony roar of the lion. That reward must come from the work itself: the excitement of the beating heart, the comradery in work you do not have to do alone, the song you sing together as you march down the hill to take up the task again. And this: the full heart at the end of the day, from doing what you believe is important and right. We are not the first to take up an endless struggle. Instruction comes from legendary Sisyphus, condemned by Zeus to roll a stone up the mountain each day and watch it roll down again. French existentialist Albert Camus believed that "the struggle itself . . . is enough to fill a man's heart. One must imagine Sisyphus happy."

The small heartenings in *Take Heart* come in the form of visual and literary art—drawings of oil barons and blackbirds, paired with stories, affirmations, and exhortations. It should not be a surprise that art is what we offer. Art flies with two wings, celebration and protest. With equally strong and steady wingbeats, it can carry us over broken ground.

Art invites us to linger, to contemplate the goodness and beauty that sustain us. The essays look to estuaries, ethics, and wings; the drawings to representative ducks and rabbits, herons and heroes—all as invitations to recall the sacramental places and companions whose presence sustains us. Stopping to see, really see, to *behold*—that ancient word—signifies that we are taken in by, held by what we regard, and that we in turn are obligated to carefully hold what we see. This fundamental attention or mindfulness may have the shape of respect or wonder or love. It may be doubled by thanksgiving.

This is essential. When the beauty of such a gladsome Earth fully captures our hearts, we dedicate ourselves to its being and becoming. Beauty is a not only a blessed vision, not only a gift glimpsed, but a task demanded. It's the mythic lover's challenge: "If you would love me, then there are three tasks you must accomplish," and off the lover goes to challenge the gods.

Art's show of lines may give shape and face also to unfaced dangers. The drawings relocate, condense, and frame the horror or violation in a way that can gain admittance to heart and mind. They can help us dare see—we who recoil from the wounds opening before us, we who resist looking at the lesions and sores, even when healing requires us to envision them fully. By image or story, or by slant and indirection, art says what has been largely unsayable: rape and plunder are savaging the Earth and its people; civilization may not survive. Almost half the birds of the air and the fishes of the sea are already gone. Two-thirds of the primates are endangered.

In this revealing, art can stir an insurrection against the machinations of the violent.

As the work for the world carries on, art provides companionship. Grief and gratitude are inseparable from each other. We are ever living between sadness and joy. We rejoice at the gift of earthly lives; we

grieve as they are foolishly and wickedly wrecked. It is art that points us to the tragic and comic boundaries of the heart. We turn to art, as to trusted friends, to find new shapes and lines, and maybe a kind of sense, in the chaotic world we are in and up against.

And so we offer this little book as a thank you gift to you, our friends, who get out of bed each morning and go off to do the good work of making the world a safer place for the plodding turtles, the kneeling protesters, the bewildered children, the laughing geese, the trembling trees, and the patched hearts.

Corvallis, Oregon, and Winnipeg, Manitoba
July 1, 2021

# 1  take a stand

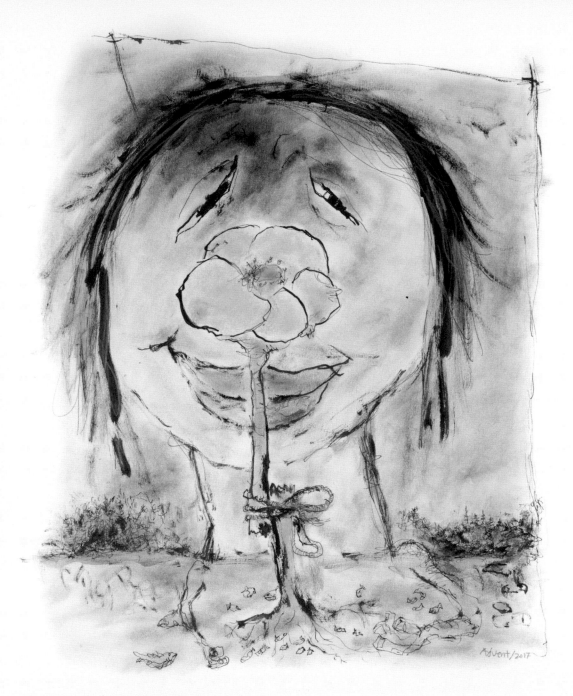

*Advice to self # 6: If you believe the watery*
*Earth can be healed, you believe too much.*
*If you think it can't, you believe too little.*

# the parable of the crab thrower

I would like to tell you a small story I read long ago—"The Star Thrower" by Loren Eisley.[1] As the story begins, the narrator is walking on a beach just before dawn. *Long-limbed starfish were strewn everywhere, as though the night sky had showered down.* Stranded above the hightide line, surely the starfish would die under the sun then beginning to rise, he thought. Ahead of him, standing in the miasma of a fading rainbow, a man stooped toward the sand. *With a quick yet gentle movement he picked up the star and spun it . . . far out into the sea. It sank in a burst of spume. . . .* "It may live," he said, "if the offshore pull is strong enough."

Can you picture this? A beach spiked with morning light. Starfish, purple, gold, glittering with sand. Two men. A starfish spinning through the air, shedding sand the way a meteor spirals sparks, and hissing into the sea. Maybe we can forgive the narrator his initial cynicism: *The star thrower was mad, and his particular acts were a folly.* It's surely true that the man couldn't save all the starfish. *The star thrower is a man, and death is running more fleet than he along every seabeach in the world.* Destruction is quick and easy, maybe inevitable. Healing is hard and slow, maybe impossible. But unconcerned, the man tossed another starfish, *skimming it skillfully far out over the ravening and tumultuous water.* He would save what he could. Even if his work was destined to fail on a large scale, that morning's work mattered. It mattered to what was saved and to all that depended on what was saved, all beings worthy and sparking with life.

1    Loren Eisley, *The Unexpected Universe*, 1969.

The powerful story, beautifully told, has stayed with me for forty years. So you might imagine how startled I was to see the same parable unfold on a different beach, with a different hero, and a different moral to the story:

Let us join a party in progress on the deck of a cabin overlooking the shoreline of a little Alaskan boardwalk town. Perched on whatever serves as a seat—an overturned bucket, a log, a railing—people are drinking salmonberry wine and catching up with their neighbors. A bluegrass band tunes up, four guys in plaid shirts and rubber boots, just off the ferry. A potluck supper is gradually materializing on a plank table, and the sweet smell of baked beans and smoked salmon rises on salty air.

The children have all run onto the beach—big kids, little kids, tiny kids clumping along in oversize boots. They are, of course, running with sticks. But in this harbor town, not a parent shouts a warning. If the kids can't figure how to dance with sharp objects without putting out an eye, they will never make it on a salmon trawler. The children roll big stones and poke with sticks, hooting and jostling. Only one kid stands apart, a lanky little boy in a blue sweatshirt, twisting one foot into the other.

Then the boy is running into the clump of kids, grabbing something from the beach and heaving it overhand like a baseball into the sea. "Stop it, you guys, stop it!" Another kid chases the boy, but he twists free, grabs something else from the beach and throws it hard. He has thrown maybe a dozen pitches into the waves when a big girl grabs his throwing arm and wrestles him to the sand.

It takes awhile before the boy can scramble up the bank into his father's arms. It takes even longer for his folks to figure this all out, the way he pants and protests. Gulls swirl, crying out. The children follow the boy up the bank, wanting to tell their side of the story. But soon they are distracted by the potluck table; with their hands behind

their backs, as they have been taught, they stare at the frosted cakes so intently, the children might be expecting them to hatch.

"What were you doing?" the boy's father asks.

"I was throwing crabs into the ocean."

"But why?"

"To save them. Justin picked up a beach crab, but it pinched him, so he stabbed it through with a stick and stuck it to the ground, and then all the other kids starting sticking crabs to the sand.

"I tried to throw all the crabs into the ocean, but Chrissy held me down."

"Yeah, because you stole Chrissy's crab," a tall boy interjected.

"It WASN'T Chrissy's crab, and she was going to KILL it."

As the banjo gallops on, the boy clings to his father and sobs.

"You did the right thing," the father murmurs into his son's damp hair. This is true.

We may imagine the father proud of his son, and maybe a bit frightened for him, because this also is true: for every person who tries to stop destruction, there will be others who try to block him. It's important to know that this will happen. Other people may hold him down. Others may laugh at him. The winds may turn against him; destructive winds ride a long, straight fetch through history. It takes moral courage to stand against their force. The beach exhales in horror, then holds its breath in hope, because when the boy throws the crabs into the sea to save them, he shows the other children that it can be done. It is possible to stand against destruction. It is possible to make some difference, if not all the difference in the world.

The boy could have taken a stand saying, "This is wrong and I will not be part of it." That's good. But even though he is small and the others are big, he says something even better. "This is wrong, and I will not allow it."

So this is how the story of the crab thrower concludes, as the banjo-beaten day slides to its golden end. And I will never forget the moral of the story Loren Eisley tells: Returning to the star thrower, *silently I sought and picked up a still-living star, spinning it far out into the waves. I spoke once briefly. "I understand," I said. "Call me another thrower." Only then I allowed myself to think, He is not alone any longer. After us there will be others.*

# 2 know you are not alone

A Carolling of the Creatures

# the dawn chorus

*There are no promises that we will see the day*
*The dreams we live for will succeed*
*But I can promise you that half way round the world*
*I'll hold the light up while you sleep.*
—LIBBY RODERICK, "Cradle of Dawn"

Have you seen the image of Earth from space, as the planet turns under the light of the sun, and morning advances? Always half spangled black, half glistening blue and green, the ball rolls, and mountains and coastlines, seas and continents slowly emerge into the sun. It stirs me, I have to say, to watch morning flow over Earth like a bright tide. There should be brass bands in little boats, bumping along the advancing edge of the flow, singing out to announce the morning.

But in fact, that's almost exactly what has happened every day for—how many?—sixty million years, scientists say, so . . . doing the math . . . 21,900,000,000 days. That's how many days birds have stirred in the breeze that precedes the day, lifted their heads, and begun to sing.

The *dawn chorus*, that's what people call it, the sequence of especially brilliant bird songs that begin the day. The voices call out, "I am strong, I am fully alive, I have lived through the night and emerged from my dark shelter to sing again." My friend, an acoustic ecologist, has followed the sun around the world, recording the dawn chorus on continent after continent, the great uprising of song as Earth turned, that tide of sparkling light advancing into the darkness, lifting song after song.

Let us pause to appreciate the magic of this planet. We live on a player piano, the rotating cylinder plinking out music as the Earth turns. No, we live on something even more wondrous than a piano; it's a magical music box, because pink morning light—not little metal tabs—plucks the strings. Who would have the whimsy and the aesthetic abandon to invent such a marvelous machine? Envious aliens, approaching Earth's orbit, would not call this the blue planet; they would call it the *singing planet*, I am sure.

Of course—how reluctantly I take this turn, but there's no denying—we are losing the music box. No. That's wrong: human expansion is destroying the music box. The same ecologist who recorded the global dawn chorus warned me. He couldn't make that recording now, he said, because Earth now has barely half the singers that once sang in the choir and some of the voices are forever gone.

Every evening, I watch as bare branches and telephone lines slice the falling sun as if it were an egg yolk, and the day darkens. There is so much work to be done to save the music, to save the habitats, to save democracy, to save decency, to save children, and yes, to save the dawn chorus. We could work all the bright day and all through the night, and still the work would not be done, and how can it even begin? I will ask: Who can let herself fall asleep, when she has not found a way to save the world?

But it is important to remember that another kind of dawn chorus circles the planet. It is not shrinking; it is growing. It is not quietening; its voice is rising to a roar. On the rotating planet, there's a great dawn chorus of committed people, millions and millions of them, who rise from their beds or mats or blankets, rustle up coffee or atole or tea, and set off to do the good work of defending the world's thriving. We can hear the chorus if we listen—the rustle, the creak of doors tin or wood or grass, voices calling out to each other in a thousand languages, the

rumble of action advancing around the world, awakened like birds by the rising sun.

As each of us falls into bed at night, exhausted and despondent because our work is barely begun, we can know that the sun is rising on the other side of the planet and other people are rising to the challenge of protecting the whistling, chattering, sighing lives—the birds, the children, the pines. And when the dawn comes, we can take up our part of the work that others, exhausted, have laid down.

Each of us will emerge full-throated from the dark shelter of our private despair. We will find our cause. We will find our chorus. We will find our courage. And then nothing can stop our collective action—not mining engineers or industrial timber executives, not craven politicians or corrupt petro-thugs. Then nothing can distract us—not football, not shopping, not even composting. There might have been a time when our lonely work for the world was in our private lives, focused on exemplary recycling or some such. That time has passed. If we are to save the exquisite gifts of this planet, our work now is in the streets, in the state houses, on the riverbanks, in the college quad, on the path by the flooded field, making our voices heard. What we cannot do alone, we will do together.

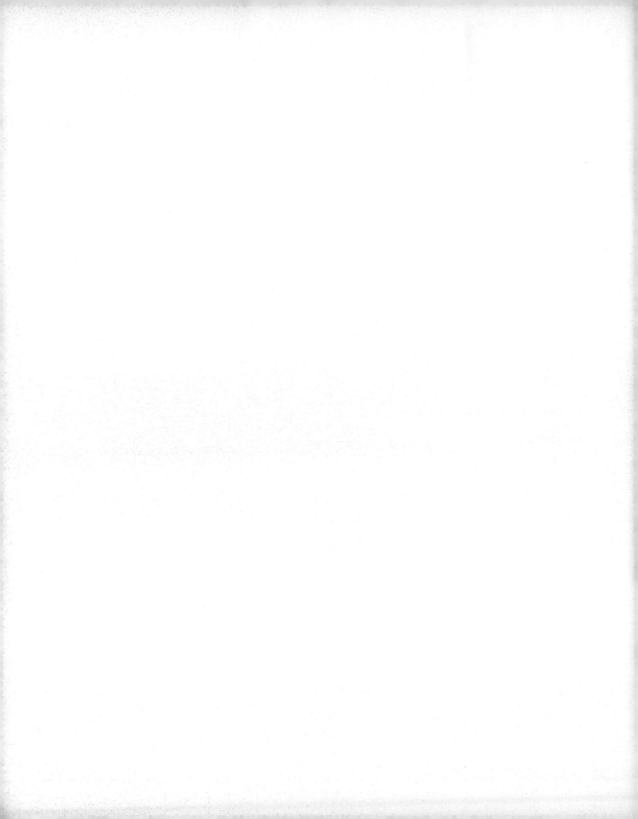

# 3 get in the way

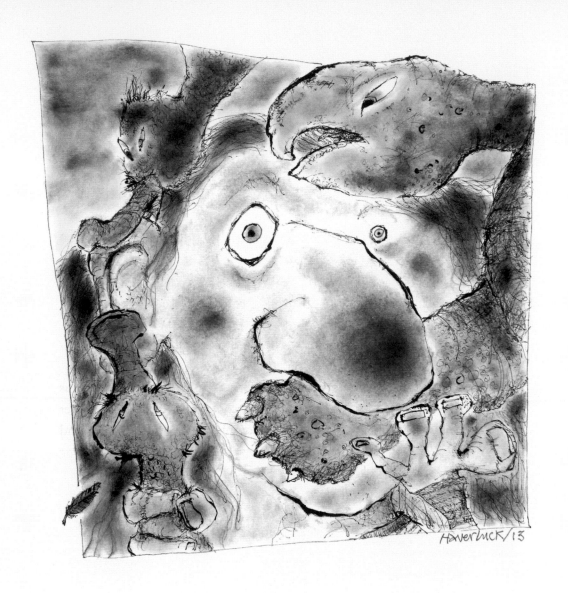

Shhh! Water is talking!

# the great avulsion

The town of Lancaster, Oregon, consists of an antique store called *Antique Store*, which makes sense to me, and an outdoor restaurant called *The Junkyard*, most likely because the entrance is marked by a rusted-out Chevy with a pile of dirt and dead chrysanthemums where the engine should have been. It's a popular place. Pickup trucks pull in, dragging clouds of country-western music and dust. Oversized dogs hang out in the parking lot, sniffing at the fence. This is what it is now, but a hundred and fifty years ago, Lancaster was a bustling steamboat landing on the Willamette River.

Located a few miles south of Sam Daws Landing, Lancaster was as far up the river as a paddle-wheel boat could go. Upstream, the river pushed up shoals, braiding into a complex weave of channels and gravel bars that blocked everything but canoes. But situated right along a navigable stretch of river flowing through the middle of the richest wheat fields and forests in the state, Lancaster had everything: warehouses, mills, lumberyards, orchards, grain and planks to be loaded for Portland, preachers and shysters and settlers to be offloaded. I can imagine rain shining on the backs of Kalapuya workers, carrying heavy loads up the boat ramps. I can imagine the algae smell of the river, the woodsmoke, the spice of fresh-cut Douglas-firs. It all would be easy to imagine, except for one thing.

Today Lancaster is nowhere near the river. From The Junkyard's parking lot, the land stretches east over grass fields, pastureland, and a couple of depressions lined with trees. But there is no sign of a river. As

it happened, just as Lancaster got really going, the river picked up and left in the dark. When people went to bed, the Willamette was flowing along past town, nice and steady. But heavy rains were falling on damp snow upstream, and sure enough, the river quickly rose into the Great Flood of 1861. The flood ripped at the riverbanks and tore out ancient cottonwoods. Sometime in the night, the river jammed up against the mud and trees it carried. With nowhere to go, the river tore open another channel. By morning, it was flowing along two and a half miles away, nice and steady. It has been there ever since.

"An avulsion," my friend Gordon told me as we walked along the gravel beach of the Willamette, talking about rivers. "That's the word for what happens when a river's force creates so many blockages that it drops its load and goes a different way."

I have never been so excited about a word in all my life. "Avulsion. Yes. That's what we need. Let us create avulsions!"

I had been in despair. The planet is caught up in a river rushing toward a hot, stormy, and dangerous future. The river is powered by huge amounts of money invested in terrible mistakes that are dug deep into the very structure of the land, a woven braid of fearful politicians, preoccupied consumers, cowardly universities, reckless corporations, and bewildered parents—everyone, in some odd way, feeling helpless. I had agonized: How could Earth's defenders ever stop a river that flows with that kind of power? But I get it now. We don't have to *stop* the river with one big dam. We just have to *jam it up* all over the place, and here's the fun part: the heedless force of the river will do most of the work.

As the current rustled by, Gordon explained the rules of rivers. "The processes of a river are manifestations of energy," he said. He's a geomorphologist, and that's how he talks. "A fast, high-energy river will carry

particles—the faster the river, the bigger the particle. But when it loses energy and slows, the river drops what it carries, creating obstacles that force it to flow in a different way. So anything that slows a river can make a new river course. It could be a stick lodged against a stone or a cow drowned at high water. A cottonwood tree, maybe, undermined by a flood. Where the water piles against an obstacle, it slows and drops its load. The load catches more floating detritus and an island begins to form. As water curls around the obstacle, the current's own force turns it upstream. Slowing, it drops more of its load, which further deflects the current. Around one small change, the energy reorganizes itself entirely."

And here's the point: no one pattern continues indefinitely. It *always* gives way to another. When there are so many obstacles and islands that a channel can no longer carry all its water and sediment, it flips and carves a new direction. "The change is usually sudden, often dramatic," Gordon said, and pointed over his shoulder into the fields where there once was a wharf.

We don't have to dam the whole destructive river. Our work and the work of every person who loves this world is to make one small deflection in complacency, a small obstruction to profits, a blockage to business-as-usual, a better way, a stoppage to the lies, then another, and another, to change the energy of the flood that is destroying the stability of the climate. As it swirls around these snags and subversions, the current will slow, lose power, eddy in new directions, and create new systems and structures that change its course forever. On these small islands, new ideas will grow, creating thickets of living things and life-ways we haven't yet imagined. Those disruptions can turn destructive energy against itself and reverse the forces that would wreck the world.

This is the work of creative disruption. This is the work of radical imagination. This is the work of witness. This is the lawsuit, the parade,

the boycott, the co-op, the newsletter—the steadfast, conscientious refusal to let a hell-bent economy wash over us. We know how to do this. Every child who has ever constructed a careful row of stones in a stream knows how to do this. We just have to wade into the silty green water with our shoelaces dancing and our socks sagging around our ankles, and start piling rocks.

Choose your stone and drag it in, people. Chuck in a bunch of stones or get together with your friends to roll in a boulder. Heave in a log or the rib cage of a drowned raccoon. Push over a dead cottonwood. Build something new. Doesn't matter what. Just get in the way.

# 4  start over

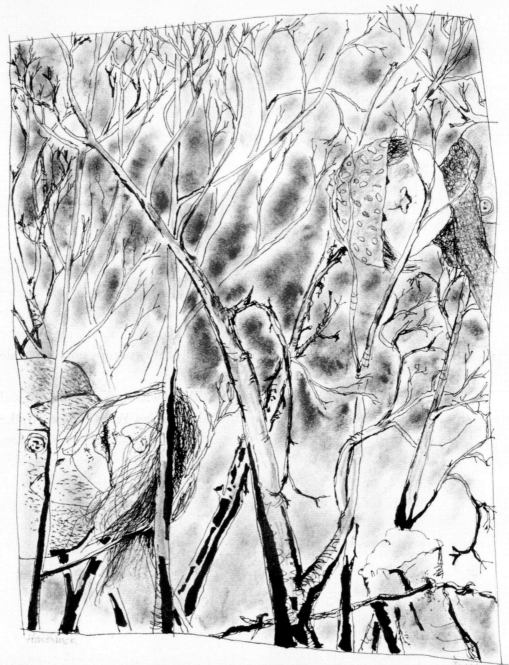

*December. Before the pail of sunlight is put away in the shed of night, it is
emptied out. This is the time to be led by some child into the barren woods.
A time to be among Saskatoon bushes, which stand naked as King Lear.
You, like Lear's fool, against all reason, await its birth.*

# the night of the ice moon

Just a few minutes before midnight on New Year's Eve and rain is pounding on the shore pines, on the huckleberry tangles, on the beach grass, on the dunes. From the smash and thud of it, the wind is hurling waves on top of waves, driving them headlong into the cliffs. Gusts of wind flush through the crowns of the pines over our camp. Pine cones and pellets of rain rap on the tarp tied tight as a foresail to our pickup truck, snapping the shrouds and showering us with a fine mist. The only reason the rain doesn't damp out the campfire is that my husband has built the flames so high and so hot that raindrops pop and sizzle into steam before they can reach the fire.

This is good. This is all very good. This is what we want, my husband and I. This is exactly where we should be on New Year's Eve, held by the same dank forces as the forest, peering into the same darkness as deer and coyotes, buffeted by the same winds that bend the trees, breathing the dampness of seas lifted on the gale. If I were in a bright apartment, raising a flute of champagne as I teetered on high heels, watching a bright ball poised to drop down the TV screen, jeering at the last year and cheering for tomorrow, I might forget where I was. But there is no forgetting tonight. We breath air that smells of sea-funk, mushrooms, and pine smoke—and drink whiskey, the official beverage of dark, thirty-four-degree gales.

I might wish that New Year's Eve didn't come in the winter in the Pacific Northwest rainforest, when the weather is always awful. January

first seems to be an arbitrary choice to mark the day when Roman consuls were appointed, or Jesus was circumcised, or ancient auditors reached for a *tabula rasa*. Far more meaningful to mark the new year on the winter solstice, the time when the Northern Hemisphere begins to turn its shoulder toward the sun, the days lengthening toward spring. Or how about following the Coptic Egyptians, who celebrated the new year when the Nile began to flood, fertilizing the fields? Or best of all, the Babylonians, whose new year was the first day of spring—truly a new beginning. It should be the Earth, not the auditor, who dictates the new start, coming into a relation with the sun and the moon that warms the soil and begins the cycle of growth again. It should mark an event that even extraterrestrials would understand was of cosmic importance.

Each year, as the Earth circles the sun—back to its beginning and then embarking again on its journey—the sun lights the countenance of the Northern Hemisphere for a few more minutes, then the countenance of the Southern, and around it goes. And what it creates, north and south, is a second chance, a chance to sow the seeds all over again and do it right this time, a chance to water the trees and reap the fruit if the frosts stay away. Last year, maybe we didn't get it right. Maybe we were careless, or forgot who we were. But there will always be a next time, and a next, a fresh start when the Earth completes its journey. And so the planet in its orbit offers a kind of forgiveness for mistakes made. This second chance is an undeserved mercy, a gift of amazing grace to the seeds, to the babies, to the freshets, to the careless or ungrateful, to ongoing life.

But now I take a long, thoughtful sip from my tin cup. I say there will always be a second chance, and I do believe the Earth will continue to turn, offering seasonal change to whatever is left of life. But the human

prospect is uncertain, and there is no guarantee that what looks like a second chance might not be a last chance. Our species has not earned the grace of new beginnings, we cannot claim a right to start again, and if that chance is taken away, there is nothing we can do to get back. But that's all the more reason to celebrate the new year, to give thanks with every breath, and to make the most of it—that's the key—to grab this chance, as if it were the last.

Maybe this is why people make promises on New Year's Eve, saying, *Okay, so I messed up last year. But this year, I will accept the chance to do better. I will be kind—when I had been cruel. I will give thanks—when I had asked for more. I will be careful of what is fragile, whether it is a growing love or a lily in the garden, a democracy or a child—where I might before have been cavalier. I will sing praises—when I might have complained. I will align myself with the rhythmic creativity of the Earth—when I had been contrary—and bring myself into the rhythms of life. This year, by damn, I will shape my life to match my values, "becoming," as Gandhi advised, "the change I wish to see in the world."*

And then there is this: Every year, the revolution of the Earth offers a new start, I am thinking, but what of the moon on its faithful travels around the Earth, never glancing over its shoulder at us, but always facing the sun? Its phases also begin and end and begin again. Every month, it also offers a celestial new beginning. And what of the Earth's rotation, bringing us again and again into the light? There's no need to wait for January first, I'm thinking; each day is a new start. Sun, moon, Earth—the rotation and revolutions of the heavenly bodies are showering us with grace. Each morning offers the weepy joy that forgiveness brings, and the exhilaration of a new beginning. This is worth celebrating, and that is what we do, here, in the dark. My husband stirs the fire, sending up an exultation of sparks.

One might think the sky would be black, black, on this New Year's Eve. But it is not. It is a deep blue, rimed with azure at the edges, cut through with glints of gold. The sky is the color of the shell of the mussel, which is the color of denim before it fades. A blue night sky in a gale?—yes, because it is not only New Year's Eve, but it is the night of the "ice moon," the full moon in deep winter. Pouring onto the clouds above the storm, moonlight illuminates the sky, and the clouds must be shining with a pink and lavender opalescence more commonly seen on the inside of the mussel's shell. Some of this light seems to find its way through the seams between storms and around the edges of the night.

But now, exactly now, coyotes begin to call. From the far side of the dunes, from the beach-pine thickets, they yip and howl, urging one another on until we have a full-scale coyote riot in the hills. My husband shines a flashlight on his wristwatch and grins. "Midnight, exactly," he announces. This happens every year. Maybe it's fireworks in a little coastal town, or a single rocket over the beach, or the pause of the moon at its apex—something tells the coyotes there is reason to sing. And sing they do.

# 5 hold hope

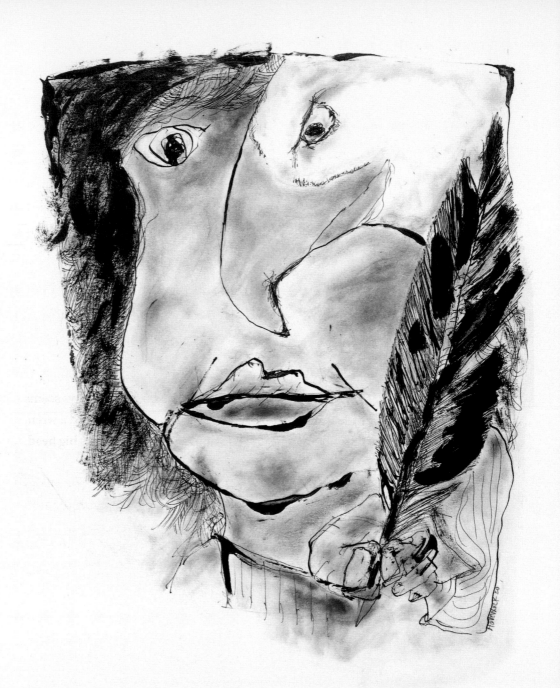

*Hope is a think with feathers*

# hope is the other thing with feathers

A long time ago, in a small house in Amherst, a young woman named Emily Dickinson sat at a table beside an open window. As filmy curtains blew over her page, she wrote her famous poem about hope.

> *Hope is the thing with feathers*
> *That perches in the soul,*
> *And sings the tune without the words*
> *And never stops at all.*

Long after, artists illustrated her poem with a bird that always seems to be a perky little thing, sort of a cross between a bluebird and a wren, with its flirty tail and open beak—a juvenile, to judge from its big head.

I protest on Emily's behalf: that is the wrong bird.

This was 1861. White supremacists were gathering in armies and marching north. Loggers were advancing through the continent's virgin forests. Black slaves, having fled rape and lynching, hid in her neighbors' barns. Malaria, typhoid, and cholera ripped through families. *The Dyings have been too deep for me*, Emily wrote. *And before I could raise my Heart from one, another has come.* If hope was perching in her soul, it was something far fiercer than a bluebird.

I'm going to suggest a bald eagle, with its hooked beak and terrifying claws: an eagle, like the one I once saw come swooping over the inlet, swing out its awful yellow talons, and grab a pink salmon off the water. The eagle flapped to rise with her prize, but her wings caught in the

waves and she fell back. Equally hopeful of escape, the eagle and the salmon raised a murderous ruckus of light and sea. Then, resigned, the eagle settled on the water and began to swim her prey toward shore.

The nearest rocky point was a half mile away and the tide was running hard. But the eagle judged her trajectory, hunched her elbows into scoops, pulled them through the water, and in this way paddled toward shore, dragging the struggling fish.

A fog bank blew in and blew out again. To the east, a cloud layer obscured the sun until up it rose, gilding the water. Through it all, the fog and the gold, the eagle paddled on. Finally, she reached the broken rocks and clawed onto shore, exhausted and bedraggled, dragging up a salmon, still flapping.

Gulls had been waiting on shore for the eagle, no doubt hoping that they could snatch some tasty scraps. This was not to be. As the eagle tore into the salmon's belly with a beak like an axe, the gulls sidled closer and closer. But the eagle had only to turn her magnificent profile toward the gulls, fix them with one terrible golden eye, and the gulls flinched, hopped into the sky, and fled.

This is what hope is in hard times. Not a sweetly singing wren, anticipating good fortunes, nor a gull, passively waiting for someone to bring him what he hopes for, abdicating any responsibility to feed himself. Hope in hard times is ferocious. It is strong and razor-sharp. It is wild. It is stubborn. It is driven. It may choose its time, but it seizes its chance with open talons and drags it to shore, no matter how long that takes. Hope uses all its strength and wile and never gives up, knowing that if it stops trying, it will drown.

In hard times, hope doesn't come to you. In hard times, you have to reach deep inside yourself for the courage and determination to keep on trying, as the climate expert Suzanne Moser told me. Hope is not an emotion. Hope is an act.

It's not a bluebird that sits on Emily's shoulder, tweeting comforting songs into her ear. Picture instead an eagle that pins her soul in its protective grasp. The eagle stands tall and straight on Emily's shoulder, lowers its eyebrows over piercing gold eyes that sight along the deadly weapon of its beak, and calls a screeching call that sounds like rocks scraping against a metal hull. Emily is right: there are no words to this song. Hope is an animal cry of rage and will.

So call in all the feathered things that are perched somewhere in your weary soul—the harpy eagles and the sharp-shinned hawk. Call in the cassowaries and the shrikes. Call in whatever character traits *Velociraptor* and the extravagantly feathered thing, *Tyrannosaurus rex,* have perched in your reptilian brain. What we need is strength—strength in numbers and strength in moral conviction. What we need is shrieking, roaring courage.

# 6 let go of what hurts you

Mourning Doves near Fort McMurray

# five thoughts about sacrifice

1.

*Sacrifice zone* is defined as "a geographic area that has been permanently impaired by environmental damage, often through locally unwanted land use." Take, for example, the boreal forest surrounding Fort McMurray near the Athabasca River in Alberta, once an expanse of wetlands, bogs, and trembling-aspen and white-spruce forest—hunting grounds for First Nations people and habitat to caribou, bears, mourning doves, and wolves. All of that is gone now—not just damaged, but simply missing from the face of the Earth. The forest is razed, the animals killed or driven out, the ground scraped away to expose bitumen mines in open pits, the hills bulldozed to make vast tailing ponds to hold toxins now leaking into the river, and the People poisoned and displaced.

This is the center of oil-sands operations in Canada, the world's largest industrial project. The scale of destruction is astonishing. Fourteen million hectares, which is thirty-four million acres, which is fifty-four thousand square miles, which is the area of New York State, or one-fifth of all Alberta. Or put it this way: the diameter of the tar-sands impact is four times longer than the diameter of the crater dug by the asteroid that ended the era of the dinosaurs. Easily visible from space as a pocked and puckered scar, this is what *National Geographic* calls the "world's most destructive oil mining operation."

The massive wound is the visible manifestation of a long chain of "sacrifices." In order to mine oil on this scale, corporations have to

sacrifice the land. When they sacrifice the land, they sacrifice the plants and animals of the ecosystem. When they sacrifice the ecosystem, they sacrifice the homeland and subsistence livelihoods of the People. When they sacrifice their livelihoods, they sacrifice their rights to life, health, fresh water, and heritage. When they sacrifice their rights, they sacrifice the dignity and well-being they deserve.

I would not use the word *sacrifice* for all this taking, taking—when *demean and destroy forever* would do just as well.

2.

*Sacrifice* is defined as the act of giving up something that you value, in order to get something else you value. The word comes from the Latin, *sacra* (holy) and *facere* (to make). *To make holy.* In the old days, people offered a sheep or lamb as a sacrifice to God, cleansing both the offerer and the sanctuary in a ritual of purification. Now, in return for immense profits, corporations are offering, to the great god Money, items of value that are not theirs to give—not the land, not the animals and trembling trees, not the purity of air and water, not the homelands or the humanity of the people. This is a ritual of moral staining—fouling what was clean, profaning what was holy, drenching corporate executives in sin.

3.

A *sacrilege* is a violation or misuse of what is regarded as sacred. It comes from the Latin *sacrilegium*, from *sacrilegus* (stealer of sacred things), from *sacer* (sacred) + *legere* (take possession of). This is exactly the word we need. International oil and gas corporations are stealers of sacred things. Here are the sacred mourning doves of Fort McMurray,

with earthmovers in their vision and lesions on their eyes. Here is a bulldozed and broken aspen tree, the sacred leaves that once danced in silver light now buried in the mud. Here is a sacred seven-year-old child of the Fort McKay First Nation, born with an underdeveloped heart. It's a sacrilege.

4.

In an essay called "The Moral Climate," activist-ecologist Carl Safina observed that the ad-men for oil and gas have convinced people that changing from an oil-powered life would amount to sacrificing their own interests to the interests of people in the future. Carl explained:

> ... Dysfunctional values married to catastrophic leadership has led us to the place you go when you are made to believe that solution is sacrifice, and that sacrifice for a just cause is not noble but, rather, out of the question. ...
>
> This refusal to "sacrifice" is actually a pathological refusal to change for the better...
>
> ... We think we don't want to sacrifice, but sacrifice is exactly what we're doing by perpetuating problems that only get worse; we're sacrificing our money, sacrificing what is big and permanent, to prolong what is small, temporary, and harmful. We're sacrificing animals, peace, and children to retain wastefulness while enriching those who disdain us.

5.

The times call for new sacrificial rituals. Let us kill the fatted calf of the fossil-fuel industries by taking away their social license to steal and destroy the sacred Earth. Let us cleanse ourselves of the oil-drenched practices that cause deep harm, renouncing dirty investments in fossil fuels, long commutes, poisoned food, and the machines of war. Let

us refuse to allow industry to make sacrificial lambs of the Indigenous people and people of color who bear the terrible burdens of energy "development." Let us find again the sacred in what we have been persuaded is only "raw material" or "natural resource." By these rituals of purification and atonement, let us—as people have done since ancient times—work to restore a right relationship of human beings to the sacred order.

# 7  bear witness

*I heard the news today! Oh boy!*

# howl

My university colleague, Michael P. Nelson, is philosopher-in-residence at the wolf-moose research project on Isle Royal in Lake Superior. One might think this is odd work for a philosopher, but it turns out that there are lots of questions to think deeply about during the long black night, when an ice blizzard blows at fifty knots against your canvas yurt and the windows freeze shut and, of course, a pack of wolves is howling right outside the door, which bangs as if it would burst its hinges.

Among the nervous questions that Michael and his biologist colleague think hard about is, why do wolves howl?

Sometimes, he says, wolves howl when they are alone and wondering where everybody went. What wolf scientists call the *lonesome howl* is a series of short howls, rising in pitch. A howl carries six to ten miles through bare birch trees and snow. So wolves howl—"I am here. Where are you?"—to find one another across long distances.

Wolves use a *howling chorus* to claim their territory and warn off rival packs. Every wolf's howl is a little different in pitch or overtones, so they can demonstrate the size of the pack by all singing together. A wolf can even try to pull off the trick of changing the pitch mid-howl, pretending to be two wolves singing a duet.

*Disturbance howling* warns of predators—bears, tourists, hunters, wolves from other packs. It signals, "I am disturbed," with high-pitched howls.

Most important, howling is a *social rallying cry*, calling the pack together physically and strengthening their social bonds. It often functions

as a call to the hunt. Moose hunting is dangerous work; a moose can smash a skull with a well-placed kick. It is generally collaborative; wolves encircle a moose, holding it at bay while a single wolf moves in to hamstring and then kill it. So the wolves need to rely on each other. In contrast, lone wolves, hunting silently through the winter forest, have to live mostly on mice and carrion.

When Michael speaks to climate activists, he sometimes asks them at the end of his talk to join in the rallying cry of a howling chorus. "Our work is perilous," he says, "and we need to come together." I've been in that auditorium, and I swear that if any wolves were around to hear this rousing, raucous, laughing, yipping, braying choir howl the house down, they would laugh until they cried. But it feels brave and good to let loose with a couple hundred other people, all that energy shaking the roof for a single cause. That's important to remember because, according to the Yale Program on Climate Communications, "more than half of those who are *interested* in global warming or think the issue is *important* "rarely" or "never" talk about it with family and friends (57 percent and 54 percent respectively). Half of us are just lone wolves, skulking around, saying nothing, subsisting on mice.

So I've been thinking hard about why it's so important to speak out about the moral urgency of climate action. Loudly. Together.

We need a howling chorus about climate change. It's easy to think you're the only one who cares, when people around you are in silent agony, embarrassed to speak out or worried they will offend their friends. In fact, Americans routinely underestimate how many other Americans think global warming is happening, estimating that percentage at 54 percent, when in fact 69 percent of Americans do. But when people don't speak up, it's easy for the titans of destructive industry to believe (and convince politicians) that people don't care enough to stop them. And those who might speak out, ask questions, challenge

power—newspapers, TV, social media outlets—don't see the profit in stories about climate injustice. You can't sell ads to people who aren't tuned in.

Wolves wouldn't worry about any of that. They howl at fire sirens, they howl at barking dogs, they howl at the moon or the Milky Way, they apparently howl for the hell of it. Howling is contagious in the pack; when one starts, the others can scarcely contain themselves. Even wolf pups utter little howlettes, practicing for the big time. When climate advocates speak out, we will find there are huge majorities of concerned and alarmed people out there, relieved to learn they are not alone. We can give voice to those who have no voices—future generations, plants and animals, small children, and the dispossessed around the world, those Pope Francis called "the silent voices screaming up to heaven."

We need a great ruckus of disturbance howling too. It's hard for people to see the looming dangers of global warming. It's especially hard for people in comfortable, protected lives to see climate injustice; we don't often see its victims, who live in red-lined neighborhoods or on other continents, or float invisibly in the future. Governments collude with industry to silence people—making a fine art of organizing "hearings" in which no one is heard, binding people to nondisclosure agreements, protecting proprietary secrets about toxic chemicals, releasing activists from jail only on condition that they do not speak out. And let's be frank: What person doesn't have a hard time seeing what would prick their conscience or disrupt their convenience? So we need a bunch of disturbance howling to call attention to the social, ecological, and moral peril that skulks around our ordinary lives, hidden in the dark of lies and distraction. No wolf worth his salt would sense danger and fail to howl to warn the pack.

We need a social rallying cry, too, calling us to the hunt for alternative paths to the future. Real alternatives can be invisible until they are

given voice. Just as people can draw attention to dangers, they can convene to create a new vision, say it out loud, and model it in their own lives. We can be clear about what we believe is right and summon the courage to speak it. Industry, its advertisers, and its public relations departments are only too happy to tell us what we should believe a good life requires (a Ford F-150). They are happy to define healthy for us (a five-year survival of toxicant-induced breast cancer). They are only too pleased to tell us who is responsible for so many low birth-weight babies in the fracklands (their mothers, of course). But we can converge on a counternarrative, a new vision of what is actually true and good, and then affirm it in every way we know how.

Some years ago, I hiked out with a wolf biologist to howl for wolves. We were to estimate the number in the pack by counting their voices. The night was so still and cold that our boots squeaked like mice in the snow and our noses froze to our mufflers. When we had hiked to the edge of a lake rimmed with pines, we stopped to listen. Never has a night been so quiet—not an owl's soft hoot, not a thump of snow falling from a branch. Stars lit the snow and the whole world sparkled. The biologist cupped her mittens around her mouth and began to howl. The sound, as clear and warm as a cello, slid almost an octave. No response. She howled again, and I yapped along, and suddenly we were surrounded with howls and yips and barks, a great uprising in wolftown behind the snowy hills. This is what we need—a full-throated howl of warning and a joyful chorus of purpose and courage ringing out in the darkest night.

# the eye in my hand

Sun on the granite shore of Lake Huron. The musky, green scent of a freshwater cove. Mosquitos. Uncle Stan and I, casting spinners for small-mouth bass. Rooster-tail spinners with pink feathers and treble hooks.

I'm not much for fishing, and of course I wasn't catching anything, but fishing is what one does in my husband's family, so this is what I was doing. Finally, I felt a tug.

"A hit. I had a hit."

"Set the hook!"

I yanked the rod. "Aah. It got off."

"Might have been weeds. But reel in and cast again."

When I reeled in, there were no weeds on my hook. What there was, was an eyeball.

"Oh my god. I caught an eyeball. I must have yanked that thing right out of a fish's face. Oh my god."

Cupped in my hand, the eyeball was staring straight at me, suitably surprised. About the size of a martini olive, the eye had a glistening iris and empty, black pupil. I was horrified. I dropped the fishing rod on the rocks and never picked up a rod again in my life. The eyeball? What do you do with an eyeball in your hand? I threw it back. I suppose I meant to give it back to the fish, but in retrospect I'm sure something hungry rose to inhale it as it slowly sank. And I knew that somewhere down in the slanting green light of the cove, there was a wary, one-eyed small-mouth bass. Half the world was lost to it—the algae-covered rocks and silver minnows, each in its swirl of light.

Now, when someone says, "he turned a blind eye," I can picture what that means—in a murky, silted way. The idea makes me queasy. And when I read the news, I can't help but think of my small-mouth bass and wonder if humans are like that fish, all of us possessed of one seeing eye and one blind eye. When we want to see something, we can turn a seeing eye. When we don't, we can choose to turn an unseeing eye. It's even possible that this ability to choose *not to see* is finally what distinguishes us from the rest of creation and accounts for our particular peril.

When I taught sophistries in my basic logic class, Invincible Ignorance was the name we gave to the deliberate refusal to see facts or other evidence that might force a person to change their mind. Not surprisingly, an entire hierarchy of types of Invincible Ignorance have evolved in the past decades. Let's give them names and list them, in increasing order of iniquity.

*The Ordinary Invisibility of the Familiar.* It is said that a fish is the last one to ask, if you want to know about water. Born to it, swimming in it, dying in it, water is an invisible matrix to a fish. Just so, privileged people can seldom see their privilege. Bosses may not see their power. Humans often do not see the air they breathe, the water that flows in their veins, the ecosystems that nourish them. Concurrently, the rich can organize their lives so as not to see the suffering of the poor. So-called developed countries can refuse to notice the suffering of those who bear the burden of our profligate consumption.

These—shall we euphemistically call them *oversights*? —have moral consequence. What is *compassion*, if not the ability to see the pain of others, and so respond to it as if it were your own? What is cruelty, if not turning an unseeing eye to the needs of others? What is criminal negligence, if not acting in *dis-regard* of the near certainty of harm. At what point does carefully cultivated ignorance become, not an *excuse*

for inaction, but a *wrong in itself?* To create the conditions for compassion requires making visible the invisible. In an unjust society, this requires moral education at a dramatic scale: street demonstrations, strikes, churches, literature, film, human-rights legislation, direct action—all the various ways people are invited or forced to encounter a reality beyond themselves.

*Ideologically Invincible Ignorance.* Benjamin Franklin, having declared himself a vegetarian, was tempted by the smell of fish sizzling onboard his ship. Ah, he thought, if fish eat one another, then mayn't I eat a fish? "What a remarkable thing it is to be a human being," he marveled, "because you can always find a *reason* to do what you have a *will* to do." Just so, it seems to be a human trait to cherry-pick facts, seeing only evidence that confirms what a person already believes and rejecting evidence for what they have already decided is false.

"Confirmation bias" is the phrase that cognitive psychologists use. "Ideologically Invincible Ignorance" suits our times, as people stubbornly seek out only those voices that build their confidence in their own ideas, and viciously, sometimes physically, attack those who might urge a different vision. The attacks extend to the four great institutions designed particularly to find the truth—a free press, an independent judiciary, universities, and science. For Ideological Ignorance to prevail, these must be co-opted or enfeebled.

The dangerous, heart-breaking moral consequence is, of course, damage to the truth itself and the values it serves. Truth is far more useful than oblivion, when it comes to mapping a safe and just course; on a perilous journey, we should treasure and protect it.

Let us call the third variety of ignorance *Imposed Ignorance*—that created *in* others, *by* others, for profit and impunity. Here are corporations

and politicians yanking a bunch of hooks through the lake with the deliberate goal of blinding the unwary fish. Although there are abundant examples, from cigarettes to vaccines, the most egregious and consequential examples come from the actions of Big Oil. Here is Exxon, whose executives knew by 1977 that burning fossil fuels caused global warming. Instead of warning the public, they helped create a coalition of fossil-fuel industries to suppress that knowledge, writing that "victory will be assured when the average person is uncertain about the climate science."

In the three years following the Paris Agreement, the five biggest Big Oil corporations spent more than a billion dollars to sow ignorance and uncertainty. It was money effectively spent. Although 99 percent of scientists conclude that global warming is real and caused by humans, 18 percent of Americans now believe it is not happening or is not caused by human actions; 13 percent say they do not know.

We humans have the gift of foresight; we can picture the world that is shimmering in our futures. We can become the wariest of fishes, fleeing the flashy lures with treble hooks, peering into the shadows in search of surprises, parsing the murkiest shores, carefully managing our attention.

Yes, here are the victims of ignorance campaigns, finning through time with an empty eye socket, ferociously defending their right not to see. But here also are the children who have a clear view of their prospects—the lonely seers. Here are the prophets in frontline communities around the world, seeking justice for the future. Here also is sunlight shafting through the murky present, throwing a wavering light on the course forward, if we would choose to turn our heads and see.

# 8 get mad

The sun is turned into sawblades, trees into forests of chimneys.

# a short treatise in defense of outrage

A decade or so ago, I did a bad thing. It's not the only bad thing I did in the ensuing decade, but it certainly stands out in my mind. Leafing through a magazine, I had come across a fossil-fuel company advertisement. Here was a photo of the cloud-splashed Earth above the caption, "MOTHER EARTH IS A TOUGH OLD GAL." I was outraged. The sexism, the disrespect, the arrogance, the danger of the implied conclusion—*Go ahead and drill her*—made me livid. So I wrote an open letter to the CEO of that company, in which I opined: "If the Earth were your mother, she would grab you in one rocky hand and hold you underwater until you no longer bubbled."

That was not nice. And boy, did I hear about it. So I want to say I'm sorry to have done a mean thing, but at the same time, I would like to offer a short treatise in defense of the outrage that prompted it.

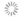

ISSUE: Is expressing moral outrage at the destructive decisions of extraction-industry executives and their government lackeys—and the consequent global warming—a moral failing in itself?

DEFINITION: Moral outrage is an extremely strong reaction of anger, shock, or indignation at a perceived moral wrong.

THESIS: Expressing outrage at the world-wrecking decisions of extractive industries is a moral obligation.

CASE: I believe in the free expression of moral outrage. Moral outrage is a public statement that an act is wrong—a wrong to me and to others, a taking, a suffering inflicted, a base and shameful act. Expressing outrage is a form of witness, a public testimony, an affirmation of public standards of what is morally permissible—and what is not. Thus, moral outrage plays an essential part in a just and decent society: The failure to call wrong-doers to account leaves the victims of wrong-doing undefended. The failure also leaves standards of right and wrong undefined.

OBJECTION #1: There's no good purpose served by pointing a finger of blame at people. It alienates them and so is counterproductive. That's not how deals get done.

> RESPONSE TO OBJECTION #1: Sorry, but I get this argument all the time, and I'm sick of it. The work of saving the planet from wreck and plunder is not the Art of the Deal. This is not Getting to Yes. This is Getting to No.

OBJECTION #2: Moral outrage has the effect of demonizing people, and it does no good.

> RESPONSE TO OBJECTION #2: It does no good to demonize?!?! Of course, it does a *world of good* to demonize—to name wrong when you see it. Silence in the face of evil is a species of violence. Can we claim to have moral standards at all, if we shudder to make any moral judgments based on them? Can we claim to love justice, if we are silent in the face of injustice? "See something, say something" used to be about bombs on trains or some such thing. Now it is the slogan of the aroused conscience.

OBJECTION #3: We should show compassion to the leaders of extractive industries. Compassion requires us to see the wrong-doer as a full

person, with his own hopes and fears. Corporate and government leaders are just exceptionally well-dressed white men trying to do their jobs in a system they did not create. Every quarter, shareholders critique their financial reports, so how can executives justify long-range decisions? In all states but one (Oregon), laws require them to make decisions based on the best financial interests of the shareholders, so how can they pass up any chance to maximize profits? The rules that might limit pollution are weak and badly enforced, so how can executives be expected to restrain themselves?

RESPONSE TO OBJECTION#3: I ask you, what is moral integrity inside a harmful system? It's refusing to play by the rules that you recognize are soul-devouring. It's refusing to play a rigged and dangerous game, even if it means giving up an annual salary of (for example) $40,300,000 as the CEO of ExxonMobil. Refusing to be complicit is a choice open even to people with gold cufflinks—a hard choice, maybe, but a choice. Moral outrage treats powerful decision-makers as responsible human beings, not as victims or helpless idiots or pawns.

OBJECTION #4: The Dalai Lama explains that "destruction of nature and natural resources results from ignorance, greed, and lack of respect for the Earth's living things." Not from some dark seed of evil deep in the soul.

RESPONSE TO OBJECTION#4: I would not contradict the Dalai Lama. But don't I have an obligation to name the ignorance, the greed, and the lack of respect, which are, the last time I looked, *vices*? Should compassion for the person prevent me from naming the horror they are creating—not as an unintended *byproduct* of their decisions, but as the knowing, directly intended or homicidally reckless, and very carefully calculated *consequence* of their decisions?

OBJECTION #5: Compassion is one of the great virtues of humanity. Is there no place left for compassion in this weary world?

RESPONSE TO OBJECTION #5: Yes. There is an essential place for compassion, but everybody keeps putting it in the wrong place. The proper place of compassion is not in deciding what is right and wrong, better and worse, just and unjust. Compassion comes after that judgment, when we are clear in our minds that a person has done wrong. Then, at that point, we confront our duties of compassion, when we decide what to do about it. Mercy then could stay the sword of justice, if that would serve the public interest. What punishment Mother Earth herself has to inflict, I can only fear.

RESTATEMENT OF CASE: Outrage is a measure of what a person cares about the most—what she loves, what ideals she affirms, what breaks her heart or dashes her hopes. It is a response that bears witness to undeserved suffering. Outrage is a testimony to love. It is one step away from overpowering grief.

# 9 get even

"O pardon me, thou bleeding
piece of earth, that I am
meek and gentle with
these butchers," begs
Mark Antony. At a clear-
cut near Lake Winnipeg.

# pogo's revenge

Pogo and Porkypine are picking their way under the overhanging limbs of a swampy forest. "Ah, Pogo," says Porkypine, "the beauty of the forest primeval gets me in the heart."

"It gets me in the feet, Porkypine," Pogo says.

The frame pulls back and reveals that the forest primeval is a dump, packed with rusted bedframes, a broken bathtub, a sprung tire, cracked bottles, industrial sludge.

"It *is* hard walkin' on this stuff," Porkypine acknowledges, sitting down on a root.

"Yep, son," says Pogo. "We have met the enemy and he is us."

Walt Kelly published his cartoon on Earth Day 1970, fifty years ago, and it still comes up in the question periods after, I think I can honestly say, every single one of my public presentations. In large part, it is a question from people of conscience who acknowledge their part in the fossil-fuel economy and are honest enough to accept the moral responsibilities that come with their decisions. Knowing they are not "without sin," they will not "cast the first stone" at the fossil-fuel industry. Fair enough.

But in equal part, the question is a challenge to the right of anyone to criticize the fossil-fuel industry, until they have purified themselves of any taint of oil, plastic, fertilizer, jet fuel. The question implies that

because no one can lay claim to this purity, nobody has the right to criticize the fossil-fuel industry. This fear of hypocrisy is absolutely immobilizing for a public that doesn't ask *why* they are dependent on fossil fuels, but rather questions their own moral standing to protest their dependence.

It may be one of the biggest triumphs of Big Oil, to make consumers blame themselves for climate change, even while the corporations are spending billions to transform us into mindless consumers of self-destructive (but cheap) consumer goods and fossil fuels—to make us blame ourselves, even as they leverage their bribes in Congress to be sure that we have no alternative ways to heat our homes or power our tools or travel to work.

So when I hear people say, "We have met the enemy, and he is us," I want to think about this very carefully. Of course, everyone should spend and invest and work and travel more thoughtfully. Of course, everyone should dramatically cut their use of fossil fuels. That said, the fossil-fuel industry is very happy to claim that they are simply responding to public demand.

But I didn't demand that they cut corners and cause an oil gusher in the Gulf of Mexico. I didn't demand that they undermine the EPA and any other agency that might control fracking under neighborhoods. I didn't ask them to lobby/bribe Congress to open oil drilling in the Arctic Ocean. I didn't ask them to create confusion about the harmful effects of burning fossil fuels. In fact, I didn't ask them to give me unnaturally cheap oil by externalizing all the costs on me and my children. Rather than responding to demand, the corporations have been manipulating public demand cleverly and pervasively and seemingly without financial or legal constraints. It's no surprise that people feel forced to participate in a destructive economy. That's the business plan.

We have met the enemy, and I am going to do everything I can to make sure it isn't me. But while the oil industry is externalizing the costs of pollution and environmental destruction on me, I will not allow it to externalize its shame.

Having said all this, having laid the blame for the carbon catastrophe at the big feet of Big Oil, having insisted on the right to lay blame, I have to admit that none of us, you or I, get off the hook. The complication is that none of my individual acts—say I buy a pineapple from Hawaii instead of an apple from Oregon—are noticeably harmful in and of themselves. It's hard to say that I'm *intending* harm; surely I'm not. It's hard to say that I'm *doing* much harm; in an intriguing analysis, climate and energy writer David Roberts does the math and calculates that the average American family each year is responsible for 1/13,750,000,000 of the increase in excess greenhouse gases. I can't vouch for that exact figure; the point is that none of us is doing much harm, but in the aggregate, over time, around the world, individual acts taken all together have an exponential effect, feeding on themselves, the way fire creates the wind that powers the fire.

What lifts my spirits is knowing that positive change works the same exponential way. If the Earth makes the great turning, it will not be because of one xeriscaped front yard + one wind turbine + one local farm + one redesigned cookstove, and on and on. It will be because imagination creates more imagination, good creates more good, respect for the land creates more respect, in a swirling whirlwind of change that sweeps away business-as-usual and upends the culture of reckless exploitation. Even as we approach a tipping point in runaway climate change, we are approaching a tipping point in the human conscience. What has been astonishing indifference has become a worldwide movement for climate justice and ecological wholeness. We have met the enemy, and

he may or may not be us. But we have also met the changemakers, and they definitely are us.

<center>❋</center>

Pogo and Porkypine are picking their way under the overhanging limbs of a swampy forest. "Ah, Pogo," says Porkypine, "the beauty of the forest primeval gets me in the heart."

"It gets me in the feet, Porkypine," Pogo says.

The frame pulls back and reveals that the forest primeval is a dump, packed with rusted bedframes, a broken bathtub, a sprung tire, cracked bottles, industrial sludge.

"It is hard walkin' on this stuff," Porkypine acknowledges, sitting down on a root.

"Yep, son," says Pogo. He leans over and starts picking up the trash. For his part, Porkypine waddles to town to poke his bristling spines into the tires of the pickups loaded with trash to dump in the forest primeval. On Mondays, he visits the halls of power, where he repeatedly pokes his elected representatives in their argyle socks. Wherever the agents of destruction look, there is that damned porcupine with the bent-up stovepipe hat.

# 10  love fiercely and forever

*Ann dries*
*in the sun*
*after being*
*delighted*
*by blueberries*
*and losing*
*all sense of gravity,*
*and falling*
*into*
       *the*
            *lake.*

# the october river

We launched the drift boat in the tidewater river when the sun first touched the water. In the Oregon autumn morning, the surface gleamed black as obsidian and as smooth. Yellow leaves sailed in shallow indentations, as if the fire in the leaves had melted the slick. Clusters of ripe blackberries hung over the water. We could smell them in the damp air—blackberries, the funk of river otters, and now and then Douglasfir trees with sweet sun in their highest branches. Because I love this river, I had chosen to come here with a philosophical project that had been tugging at me for some time: to get clear about what it means, exactly, to love a place.

My husband took the oars and guided the boat as the rising tide carried us upriver. This is a McKenzie River drift boat with a high bow and long sweep oars, built for rowing in rapids. But on the languid tide, Frank had only to pull a port oar to send us swirling toward river left, or lean back on the oars to avoid a snag. He is a masterful oarsman who sets the boat sliding with the smallest gestures. I was in the bow with my journal open on my lap, glad to be so near the water that I could smell it and feel its coolness on my face. *Number one*, I wrote, *to love a place is to want to be near it, physically.*

Reflected light fluttered over the white trunks of the alders and up into maples just turning red. Frank slid us around a bend into deep shadow that still held the morning mist, and then back into that thin yellow light that autumn brings. *I want to be joined to the place, taken in by it, lost in it: this is surely love.* I wrote that down, *Number two*, then I

lay prone on the bench seat and dragged my hand through water colder than I expected it to be.

Frank tied a muddler minnow onto his fly line and cast into the shadows. Before the day was out, we would have explored every eddy and deep pool in this stretch of the river, in every light and no light, under overhanging trees and on the landward side of maples fallen across the current, and this is part of what it means to love a place, isn't it? *Number three: to want to know everything about it—its stories, its moods, how it moves deep down.*

Our plan was to pitch a tent at the head of a water-carved island and spend the night, but we found that the water was too low to float us over the gravel riffle to the upriver sand where we wanted to camp. Frank had to climb into the river and drag the boat upstream against the current—a maneuver he thought he could accomplish without filling his boots, but in fact could not. Once he had set the anchor and tied off on shore, we offloaded our gear and pulled out smoked salmon and a couple of bagels and beers. We napped on the sand then, my head on Frank's shoulder, my leg thrown over his. To love a place is to *rejoice in the very fact of it,* shaped by fallen trees and sand, scattered with sunlight. That became *Number four* in my journal.

By the time we got moving again, a shallow, light-shot mist blanketed the pool upstream from camp. Frank had no idea how beautiful a vision he made when he rowed out to fish. The boat was hidden in mist that grew more deeply pink with every cast. He looked like a man standing up to his knees in a cloud at sunset, throwing a glistening line that uncurled slowly, gracefully, and disappeared. I imagined that he saw me as floating too, and vanishing. When you love a place, you can be *transformed in its presence—lifted, lighter on your feet, transparent, open to everything beautiful and new. Number five.*

At five o'clock sharp, the steam whistle tooted across the valley from behind the western ridges. It was time for the loggers to kill their engines, gather their chainsaws, and head for the crummy that would take them back to town. I am afraid for the river, and that's part of loving a place too: write that down. *To fear its losses and grieve for its injuries*, which are real in ways we are only beginning to understand—the mud-stained streams that already drain into the river from steep slopes logged to dirt, the smudge in the air from slash fires invisible in the west, the dead crayfish on the bank, the empty salmon holes.

Truth be told, camping, I am always a little bit afraid at dusk when the light thins and the air turns cool. Darkness erases one tree, one rock ledge after another. So much of what I love stands to be lost. On wind swirling in from the sea, I smelled the smoke from the slash fires and the pong of the mud under a tide in the fourth low-water year in four years. A gust carried a flurry of yellow leaves across the gravel bar, drove a dragonfly into the blackberries. Frank rowed back to shore against an upriver wind. We dug holes for the sand anchors that would keep our tent from rolling into the river if a storm came in. It was suddenly cold.

I had known all day that there was something important missing from my list, but I was struggling to put it into words. Loving isn't just a feeling. It's a way of acting in the world. Love isn't a sort of bliss, it's a kind of work. To love a place is to care for it, to keep it healthy, to take responsibility for its thriving. I pulled out my journal and wrote this down. *Number seven: to love a place is to protect it—fiercely, mindlessly, maybe even futilely.*

There always comes a time on an island—after supper, after a sip or two of bourbon—when moisture rises from the sand. A flashlight shoots a white tunnel through fog, and every stone, every stranded log shines. That is the time to crawl into the tent.

It isn't easy for two people to hold hands when they are both zipped into mummy bags, but I wriggled a hand free and groped for Frank's, and that's how we lay, my hand wrapped in his. How much I love this long-legged man. I rejoice in the very fact of him. I want to be near him, physically. I want to be joined with him, taken in by him, lost in him. I feel transformed when I am with him—lifted, transparent, open. I want to know everything about him—his stories, his moods, what his face looks like by moonlight. Desperately, I fear for his losses and grieve for his injuries, which are real in ways we are only beginning to understand. But I will protect him all my life, fiercely and forever.

# 11 celebrate life

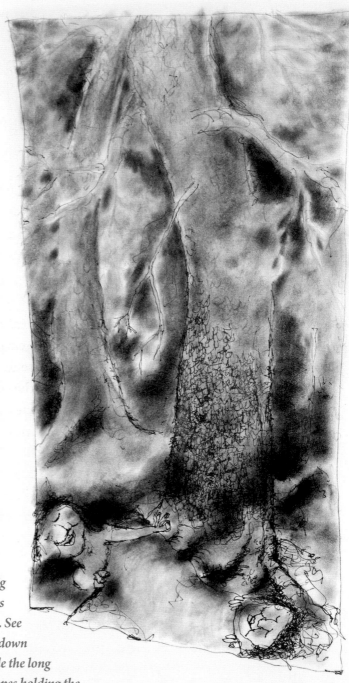

*Shoreline ritual #9: Wait until the big winds come, push, power, bend waves against the sandy earth of shorelines. See the old spruce trees. Tall. Green. Lie down there. Feel yourself rocked, as you ride the long undulating roots. A thousand tiny ropes holding the tree to the Earth . . . holding Earth to the trees. And so —by God!—we are held by what we cannot see.*

# we are held by what we cannot see

Seven in the morning. Forty-seven degrees. October 2. I'm up to my knees in sage and rabbitbrush along the wide expanse of the Summer Lake playa. Perfectly flat for forty square miles, the playa is the chalky white bed of an ancient, landlocked lake. Beside the empty plain, I stand at the center of the six directions.

To the east, through the haze of the alkali flat, I can make out the low line of the Diablo Mountains. Behind me to the west rise Winter Ridge and Deer Head Mountain, barren and grey after last week's wildfires. Black spars stud the slopes, all that remain of juniper groves and lodgepole pines. A few lines of smoke rise from stumps still smoldering after the burn. From the south come the complaints of cattle; from the north, the rolling rattle of sandhill cranes. Overhead is the inverted bowl of the sky, painted blue in the deepest reach of the bowl, with stripes of pink at the rim. At my feet is a spiral of stones that someone arranged here in a time before I came, grading from greenstone to blackest basalt to brick red and, at the center, a starburst of ochre rhyolite and pumice.

The full moon is setting at my back. As it touches the ridgeline, its broad yellow face silhouettes burned spars, as black and limbless as telephone poles. With perfect synchrony, the sun is rising across the playa, sliced through with pink cirrus stripes and a thin layer of smoke held by cold air over the flat. A quarter circle of sun emerges, a half circle, three-quarters—can the Earth be turning this quickly?—and the sun escapes the mountains and stands alone. I have seen this color before:

a tangerine's skin or the orange lip of a blue mussel or, better, the blush at the stem end of an apricot. No breeze stirs. No bird calls out.

In places only a hundred miles away, in times only a few days past, microwaves, radio waves, electromagnetic pulses, and who knows what else shot through my body day and night. My car passed other cars at a combined 140 miles per hour. The hammer of the news cycle struck incessantly, faster and faster, impossible to sustain. Deadlines grew shorter, to-do lists grew longer. Electronic messages doubled, tripled, doubled back on themselves. FYI, BTW, LOL. No wonder that, as the Earth hurtled through space, I felt I was leaning into a stiff wind, my hair blown back, my arms wheeling, staggering to stay in place.

But for this moment, in this place, I am held in perfect stillness by what I cannot see.

I am held in the arms of gravity. The moon would pull me west, the sun would pull me east, but the Earth holds me to its fiery heart.

I am held by the atmosphere that clings tight to the Earth. The spinning planet moves the air, bringing the smallest wind and the sound of trucks on the ranch road. But I will not be blown off the face of creation, because I am held by the sky I cannot see.

I am held in the pause of the moment, halfway between deep time and deep future: this moment—the time of a forty-mile, cow-stirred flat—between two lake-times. Fourteen thousand years ago, there was the old lake flush with freshwater lapping against mountain benches, its marshes stirred by elephantine legs of mammoths and a juniper-wood paddle pushing a tule-reed canoe. Fourteen thousand years to come, there may be a new lake, steaming maybe, bubbling with red anaerobic algae that stain the beach.

I am held in the history of evolution. I am neural pathways of giant birds and the tensile strength of tendons in the fins of swamp fish. I

am afraid as a darting lizard was afraid and for the same reasons and according to the dictates of the same hormones. The evolutionary heritage holds me in spider webs woven of joining together and diverging—a tight and glistening place to belong.

I am held by the exquisite balance between being and becoming. Ancient Greeks struggled to understand how the world could be both eternal and changing. What is permanence in the face of change, or change in the face of permanence? They imagined the world was shaped by elements of fire and water in endless warfare—phalanxes of fire advancing over the ridge, only to be quenched by rearguards of drenching rain; or puddles on the playa boiling to a skin of salt under the savage rays of the sun. But I would rather instead imagine being born of a steamy, torrid *romance* of the elements, fire and water, bucking and biting until—for a moment—they rest, sated, in each other's arms. We are held by a passion we cannot see.

A north wind is lifting the dust now, and the sun has diffused into a vague glare. I will return through the sage to my desk, because I need to say this to you. No matter how frenzied you feel, no matter how shoved and strangled by the rush of events, you are standing in a single exquisite moment. No matter where you are, no matter how lost, you are standing at the perfect center of six directions. No matter how off-kilter you feel, you are standing in a place of perfectly balanced forces. Even if you feel abandoned by all that might comfort you, you are held in the embrace of what you cannot see.

# nuts and geese

### I. Black walnut *(Juglans nigra)*

Two doors down and catty-cornered from our house on College Hill, a black walnut tree is growing between the sidewalk and the street. I don't know how old it is, but old. Its massive roots have lifted the sidewalk and its trunk has engulfed the fence post, so the sidewalk rises like a breaker and the fence tilts hard to starboard. In the first dark rains of fall, walnuts drop onto the street one after the other, and when wind shakes the branches, nuts thunder down like hail. In a slick of wet tires, cars roll over the nuts, popping the shells with the sound of a shot.

Three crows pace under the tree. Then, gathering courage, they stalk to the curb, look both ways—this eye east, that eye west—hop into the street, and begin to peck the meat from the broken shells. Grey squirrels go after the nuts too, running headfirst down the tree and into the street. Because squirrels do not always look both ways, cars skid and pop through windrows of nuts and wet leaves.

All this by way of saying that I wasn't surprised when a two-foot-tall black walnut tree appeared in my rose garden. I found another growing behind the garage, and another coming right up through the kale plants, four feet tall with pinnate leaves on long stalks. Either the squirrels and the black walnut tree have entered into a plan to restore the gardens to forests, or squirrels have a hard time remembering where they buried their nuts. I think it's more likely the latter, because I have watched a squirrel frantically dig up an entire bed of herbs, swearing quietly and spraying herself with dirt.

But there may be something to the restoration-plan hypothesis too. What is a nut but a forest restoration project? What is a nut but an enticement to another creature to carry it to a distant place and bury it in loose soil, where it can germinate and become a tree? Who could imagine a cleverer way for a tree to populate the neighborhood with its offspring? Even if my neighbor should someday commit the sin of cutting down that magnificent tree, small trees would grow in all his gardens, and ours, and our neighbors', for years to come. If we didn't pull them out by the long root, in twenty years, we would live in a walnut grove.

When I sit at a window streaked with rain and stuck with brown leaves and think of the work it would take to restore all we have taken from the poor, struggling planet—if it is even remotely possible—I like to think that the plants will be working right alongside us, restoring themselves by a far more efficient plan than we could ever devise. There is an urgency to life that will not be denied. If we humans should end up driving off the climate-cliff into history, I like to think that great groves of black walnut trees will grow on College Hill.

## 2. Coho salmon *(Oncorhynchus kisutch)*

Although he was raised on College Hill, our son now works along the northwest Pacific coast, studying salmon. Standing in freezing water under a steady pall of fog and rain, counting quicksilver salmon, he loves his work. This year, he and his students are using remote sensing to map changes to tidewater glaciers and project what that means for the salmon. The numbers tell a bittersweet story: as the glaciers retreat under the ferocity of global warming, they are creating new rivers—or revealing ancient riverbeds—that flow through cobble flats to the Pacific. Salmon are already finding those rivers. They shimmer upstream to brand-new gravel beds, where they deposit the eggs that will become the first generation of salmon born to that silty blue water.

I have walked up one of these new rivers, toward the shredding face of an Alaskan glacier. We began at the mouth of the river, where we anchored the skiff near a wide flat of glacial till. Deep tracks of grizzly bears and the tracery of sandpipers marked the sand. The river was uniformly shallow, maybe twenty feet wide, braided and confused from having bounced over so many rocks. As we walked along the edge, our boots sank ankle-deep into sand—hard walking—but it was even harder walking over fields of mud-slicked cobbles the size of heads. A crawling plant that we called *Einstein* for its white shock of seeds had already made a foothold in the gravel, and here and there, a seedling willow tree poked from a crack in the mud. With each step we took toward the glacier, we crossed onto younger land until, at the base of the glacier, the flat was newborn. There, the river slid full-bodied from a blue amphitheater of ice.

I had always thought that salmon returned to the streams where they hatched, faithful to their place. But some salmon stray, our son says, swirling at the mouths of the new streams and bursting upriver at high tide. One of the things that gives him hope for the wild, reeling world, he says, is the persistence of salmon. He has seen them struggle upriver after their humps were bitten off by bears. At the base of waterfalls, he has snorkeled in the smack and glory of falling fish, as they leaped again and again to gain the upper river. And now he has seen them taking advantage of change, striking out into a brand-new world to try their luck.

For four to six million years, salmon have struggled upstream, their blue backs shining, their bellies heavy with eggs. The Earth has warmed and cooled and warmed again. Glaciers grew and receded. Rivers were engulfed and revealed. As mountains rose and eroded and beaches grew and sank, salmon rode the changing currents. Salmon have seen the first kayaks make landfall on the glacial till and the first seiners drop

their deadly nets. And still they circle and surge upstream, driven by—what, if not the irresistible necessity of ongoing life, an urgency built into the shimmer of their scales and the swell of their flesh.

### 3. Cackling geese (*Branta hutchinsii*)

In a rare break between November rains, my husband and I stood on a gravel road that crosses a marsh in a wildlife refuge south of town. All brown cattails and grey water, the marsh lay flat and unreflective under a sky heaped with clouds. Thousands of geese were in the air, some in straggling chevrons, some blowing around like ashes—from every direction, aiming toward the marsh. Strings of geese tangled overhead as they circled, and still more long lines unraveled from the clouds. They were cackling geese, and well named; their yakking filled the air, some honking, some seeming to skreich like a distant frog chorus. Around and around the flocks flapped on final approach, as one goose and then another set their wings and crash-landed on the water. The birds shuddered down shoulder-to-shoulder and rested, muttering. Now and then, one stood on the water to flap its wings, then shook head to tail and settled back down. On the marsh, there was the peace of a long journey ended for the day.

We saw the bald eagle before the geese did. Its white head and tail stood out against the branches of a cottonwood tree. We swung binoculars in its direction just as it leaned forward and dropped into a low glide over the geese. Like splashing water from a dropped stone, every goose lifted off. The noise was thunderous—smack of goose feet, flack smack of goose wings, geese on the rise, wild-goose cries. At first there were more geese than would fit in the air over the marsh, but as they lifted, they sorted themselves into layers of clouds and lines, strings and V's, and began again the long and patient circles. Not finding an easy

target, the eagle eventually flapped over the rim of cattails to the east of the marsh and disappeared into a cloud.

Who among us would have risen straight into the flight-path of an eagle?

I think my instinct would have been to hide under the nearest goose, or sink low and submerge my head to make myself look as much as possible like mud. But those birds, every one of them, shot straight into the air where the eagle was swooping. The courage of geese: I shake my head. Or if not courage, then maybe a cooperative strategy, devised over eons, to offer themselves in such numbers that they overwhelm and confuse the force that would kill them. Or maybe it's a strategy coupled with some undeniable will to live that seized them all at the last possible moment and sent them into the sky. The will to live, philosopher Arthur Schopenhauer's *Wille zum Leben*, the "incessant impulse," the insatiable striving, that charges the planet with life.

In my study upstairs in our little College Hill house, I last week received an email message from a man I didn't know, a Canadian, Gene Miller. Mr. Miller edits a website to "gather and present news and perspectives about collapse—social, systemic, structural, national, cultural, ecological." How he bears to do this work is beyond me, although I'm sure it keeps him busy. But right in the middle of all that assembled horror, this sentence bubbled up.

*It wouldn't hurt to acknowledge, however wistfully, . . . [that the astonishment] of this place is that it works—staggering ecological magic, unique, for all we know, in a universe of failed experiments and near-misses.*

"Yes," I said aloud. Even as bad news bears down on us, we should remember this: it works, this communion of nut and squirrel, mountain and salmon, goose and eagle, and infinite others. It works. Not always, maybe not smoothly, but well enough; and when it doesn't work, life

bustles in to try a new unfolding. Sure, Earth-life has had some near-misses. That asteroid, for example, and maybe that new species, *H. sapiens.*

But from the craziest assortment of knees and fir-needles, feathers, songs, scales, tongues, intestines, beauty, flight, and float-bladders—who could list the elements?—time and the world continue to evolve lives that create lives, and will until the bursting sun engulfs them all. Lives that insist on living. Lives that love life itself. The will to live: What is it? How does it come to be? Where does it reside? The answers to those questions hold Earth's magic and mystery.

# 12  be open to grief

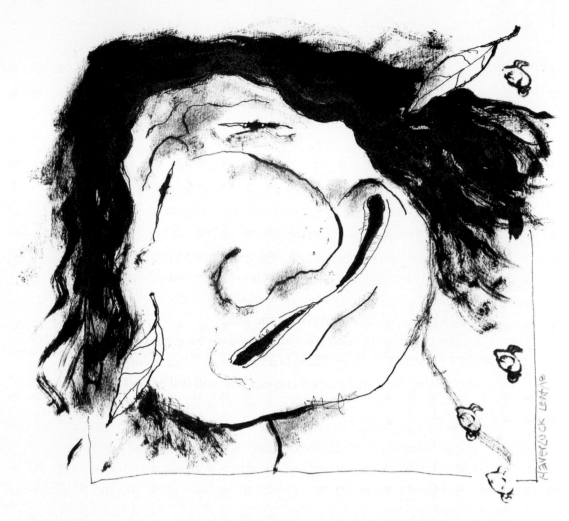

Advice to Self #3: Because your eyes have seen
forests ripped from the earth, seen the sorrows of
rivers, destruction of the animals, your eyes have
become wounds. They need to weep, cry out
earth's sorrow, cry out for earth's mending.

# if grief comes knocking, open the door

If you love anything finite on this Earth, there will be nights when grief knocks at your door. When a lively marsh dies under an asphalt parking lot. When another old woman dies alone on a ventilator. When a dam fails and fracking waste spills into the water supply. When yet one more child, dulled by lead poisoning, gives up on life. When yet another Black man dies at the hands of police. When a cormorant lands on a shining lake of oil. There will be many occasions for grief. Then comes the sharp knock in the night. Confused, you crack open the door. The moon lights the front walk. Is anyone there?

You might quite reasonably slam the door on grief, telling the children, "Go back to sleep. There is no one there." But if you crack open the door again to make sure it is gone, grief will still be waiting for you on the doormat, shoulders slumped, eyes averted. Invite it in, then, and close the door softly behind it. "I expected you, old friend. Come in."

Sit close and rest your head on grief's shoulder. Grief has grown wise and strong during life's long lease on Earth. It knows what to do. Grief will sit beside you on the edge of the bed and support your weight as you lean against it. It will put its arm around you, if you start to shake. It will stroke the side of your cheek. While it hums as tunelessly as a mother bear, it will comb the tangles out of your hair. It will make you a cup of tea.

Great grief comes only to those who care greatly. If you had no love, you would have no grief. If you cared not even a little about the marsh, the stream, the sick ones, the cormorant, the dead man and bewildered

child, you would pass the night unaware and snoring. Grief is a measure of the magnitude of the loss you feel. It is an affirmation of the meaning of ongoing life, a declaration of never-ending love, a ceremony of honoring, a howling yes.

Be grateful for grief and understand why it is a necessary gift. That you love the reeling world, that it is worthy of your love, that your love requires you to act in its defense: those are the three great truths that grief teaches.

But now. This part is important. If *despair* should knock at your door, double lock the latch, turn out the porch light, and pretend you are not at home. You will be able to recognize despair this way: while grief is a measure of the magnificence of meaning, despair denies all meaning and repudiates the possibility that anything is worthy of love. The anticipation of grief calls you to action to defend what you love; but despair, with a sullen wink, relieves you of all responsibility. There is nothing worth putting yourself out there for, despair says; nothing is worth caring about.

If you peek through the blinds, you may see despair pacing your front walk, casting a long shadow under moonlight, smoking a cigarette and scowling as it waits for you. Let it pace there until the soles of its shoes wear away and its blisters burst. Let it frown until its face falls off. Let it wait forever. You have better things to do with your life. Slip out the back door and go on with your work of loving the world.

# 13 express gratitude with good work

Ritual #4: Take another broken
heart string from seeing another
creek and wetland wounded. Use it
to floss out the foolish notion that
we should only act to oppose the
wounding if we know we can win. Maybe
we act because it is a way of giving
thanks for the gift of a ride on this ball of
fire wrapped in water, stone and morning air.

# the call of the lost cause

*Warning: The following story contains material that is very sad. I'm sorry. If you are feeling fragile, maybe you should skip to the next story. Seriously.*

No one expected the huge dog to attack the tiny dog with that sudden terrible ferocity, least of all the woman who had put both her dogs in a single travel crate for the two-hour ferry ride from Hoonah to Angoon. When I came on the car deck, the Doberman was penned in the crate, barking. The little terrier lay silent on a towel, his tufted hair matted with slobber and blood.

Two women knelt over him. A small crowd held back, horrified. The woman who was holding the dog's front paw and crying was the dogs' owner, I was told. The other, who was caressing the dog while she held bloody rags to the dog's throat, was a nurse who happened to be on board.

"Do they think the little dog will live?" I asked no one in particular.

"No," the nurse said, lifting her eyes to stare at me with what I took to be reproach. Then she turned her attention to the ferry boat's first aid kit, pulling out sutures and bandages and shaking her head.

The green seas of the bow wave curled past the gaping door of the ferry. Gulls flew alongside, turning their heads to study the events unfolding on deck. As we churned past hemlock forests and yellow-flocked tidal flats, the nurse leaned close and murmured to the little dog. For two hours, it was this way, past navigational buoys and

bare rock islands. Eventually, the crowd returned to their books. For two hours, the dogs' owner cried. For two hours, the nurse stroked the dog that lay limp in her lap. I don't know if the dog was dead or merely doomed. I was afraid to ask.

There was no possibility that either woman would leave the dog to its fate. They were called, somehow, to tend to the lost cause. I'm not sure why. But this is a fact worth thinking about, I believe, because we are faced with so many lost causes, and we have to decide how to respond.

I don't know if the work of defending the Holocene—the lovely, welcoming, life-graced world that we evolved in—is a lost cause. No one knows. No one can say. But we have to acknowledge the chance that there is no return. Respectable scientists warn that we have already crossed too many thresholds, set in motion too many feedback loops, cut too many arteries, waited too long to stanch the flow of brutal, endless extraction. Earth will continue to exist, but the life we know and love—the piney forests and wild whales—may be bleeding out. I'm sorry, but somebody's got to say it.

And yet, and yet, the lost cause, if our world is a lost cause, calls us to fall to our knees and attend to it. I want to find reasons to care for the beloved, reeling planet—reasons that don't depend on the odds of saving it.

Here's a reason: it's important to say that the projected passing of the Holocene is not an all or nothing thing. Climate change is like a leak in a boat; there are degrees of danger and, to some extent, these are under human control. By kicking on the bilge pumps or planking over a hole in a boat's hull, deckhands can probably keep her afloat until they limp into port or find a place to beach her, although they will be working hard and the outcome is uncertain. But if they do nothing, the boat will surely sink. In much the same way, a moderate rise in Earth's temperature is probably survivable for many species, including our own; a large

rise may not be. It makes no sense to give up the struggle because you can't be confident of success. It makes no sense to do nothing about climate change because you can't do everything.

But there may be a stronger reason to continue the work of healing the Earth, even if success is uncertain or impossible—that is, because it is the right thing to do, whatever comes of it or nothing, even if nothing. A person of integrity does what she thinks is right, regardless of the consequences. She acts lovingly toward the Earth, because she loves it; she lives simply, because she doesn't believe in taking more than her fair share; she protects children, because that is the duty of all adults; she protects the Earth, because she isn't the kind of person who wrecks a place before she leaves it—in every case, regardless of the payoff.

So along this coast, people push stranded whales back into the sea, although the whales often return to die. They wipe bunker oil from cormorant wings, although the birds seldom survive the toxins. With kayaks, they block a barge carrying oil-drilling equipment to the Arctic, although the barge will eventually make its way north. There is meaning in the trying and satisfaction in shared work. Regardless of its outcomes, the work is beautiful in itself, out in the wind and seagull wings. It is perfectly aligned with the life-urgency of the gleaming planet and their love for it, the cleansing rhythms of waves and tides, the creative energy of devoted people.

But this may be the best reason of all: my friend Bob Haverluck says that we should give up "the foolish notion that we should act to oppose the wounding only if we can win. Maybe we act," he suggests, "because it is a way of giving thanks for the gift of a ride on this ball of fire wrapped in water, stone, and morning air."

I stared out the door of the ferry to steep mountainsides. Yes, we can work for the Earth simply as a way to give thanks. Give thanks for the ball of fire: the center of the Earth is hot enough to melt iron. Give thanks for the water that wraps the rock: a light-shot wave rolls from the ferry's stern, revealing the

silhouette of a porpoise. Give thanks for the stone: black basaltic rocks, polished for a billion years to a high gloss, shelter orange sea stars and barnacles blue as twilight. Give thanks for the morning air: on thin, cold light comes the smallest scent of diesel fuel and the song of a flute from the upper deck.

The ferry is rounding the point into port. As they ready the ropes, deckhands move respectfully around the small pietà—the slumped woman, the healer, and the dog. The ferry lurches as fenders bump the pilings. Engines shudder, shutting down. The nurse lifts the little limp dog with great gentleness and places him in the arms of the woman who has loved him long and hard. Do we not owe the reeling Earth at least this much?

# 14 let your heart break open

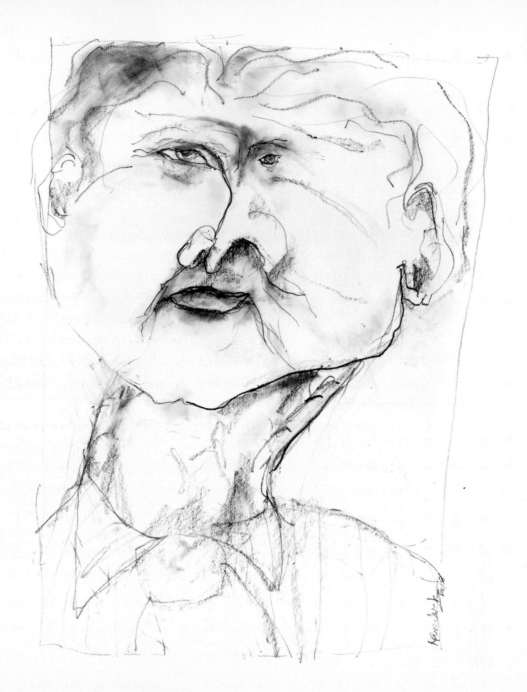

*Man dying of an unbroken heart, as he looks*
*but does not see: rivers (polluted), trees (sick), Earth*
*(mourning), and the coming sorrow of his children's children.*

# love in the time of sickness

Perched on the bird feeder outside my study window on a January morning: one male Nashville warbler; a pair of Townsend's warblers, already as bright as spring; a flock of bushtits, swarming, more like bees than birds. The Steller's jays are busy eviscerating the suet in its hanging cage, which suits the juncos and towhees, who pick crumbs off the path below. I have rigged a lightbulb in the hummingbird feeder so the sugar water doesn't freeze, which attracts a pair of Anna's hummingbirds. The birds delight me. But the weather has been violent and I worry about them. Worrying about birds poses a sort of problem, because I have been sitting by the window reading Thomas Merton, the Kentucky Trappist monk who died in 1968.

He wrote, *Someone will say: you care about birds. Why not worry about people? I worry about* both *birds and people. We are in the world and part of it, and we are destroying everything because we are destroying ourselves spiritually, morally, and in every way. It is all part of the same sickness.*

I'm not sure what to think. All of us—masked and sanitized, fenced in by plexiglass and fear—know about pandemic sickness, how it can spread and strike. But a pandemic of soul-sickness? Is there even such a thing, really? If so, what sort of illness is it? Is it one sickness, or many? Is it new, or a variety of what we have seen before? Where did it come from? What explains its destructive power? Can we find a cure? All I have are questions, probably the same sequence of questions that scientists asked about COVID-19.

But there is something very different happening here, if Thomas Merton is to be believed. The coronavirus comes from outside us to do us harm. Is Merton right, that the soul-sickness comes instead from ourselves? If so, from what seed does it grow?

Climate leader Jay O'Hara says that our plague is the *desire for the comfort, convenience, and supposed security that come from control and domination.* Historian Ibram X. Kendi says the origin of the sickness is *not ignorance and hate, but self-interest, particularly economic and political and cultural.* Heather Cox Richardson says that it's *toxic individualism* that has caused a *traumatic rupture* between people and the Earth, people of different races, the rich and the poor, the present and the future.

I wonder if they are right, that this soul-sickness is a kind of selfishness so bloated that we have become solipsists, imagining ourselves the center of a world of our own imagining, saying: *Whatever I believe is what is true; whatever I want is what is necessary; whatever I can see is all that exists; whatever I fear is what is dangerous; whatever privileges me is only just; whatever pride I feel is richly deserved, as is whatever cruelty I inflict. The only pain that matters is my own; maybe it's the only pain that exists. When I look in a mirror, it's my aching, distended ego that looks back at me, the veins in my forehead swelling and pulsing like the sun at the center of the universe.*

But this doesn't ring true to me. If people are this self-absorbed, why are we so lonely? If we are so blinded by our own dazzle, why are we bedazzled by the beauty of a thunderstorm or a child? I am more drawn to the explanation suggested by the drawing at the start of this piece—an agonized portrait of a man dying of an unbroken heart. Could it be that our sickness is a failure to love enough, the failure to be cut to pieces by the suffering of others, the failure to grieve the

destruction we cause—in short, a failure of the moral imagination that fuels empathy?

Maybe this is true, that we privileged people have not loved enough. Is it possible that we have not sufficiently loved the poor and fragile, the threatened and endangered, the brown children and the birds? Have we have systematically undermined the ability of humans and other animals to get food and shelter? Have we poisoned their neighborhoods and meadows, or allowed them to be poisoned? In how many ways have we have darkened their skies and dimmed their cities and drowned their music under the industrial din? Maybe sometimes, in secret places in our minds, have we have allowed ourselves to think, *What is it to me if they are hungry or cold or displaced from their homes? What is it to me if their habitat is bulldozed, their means of subsistence is destroyed, and their offspring die of hunger or despair? If extinction and misery are the price to be paid for prosperity, how convenient that we can send the bill to the animals and to the poor and displaced.*

But then, weakened, they die, and we are astonished. We protest: *We loved the butterflies. We loved the grosbeaks. We loved the wise elders with their rheumy eyes. Just not as much as we loved other things.*

How long have we, without noticing, breathed the dust of meadowlark nests crushed in the farmers' combines? We inhale the molecules of what the vultures leave of the truck-struck skunk at the side of the road. We breathe the exhalations of exhausted mothers working three jobs and the poisoned sweat of field workers. What remains of owls, ancient forests, or injured loggers in the wide cedar beams in our homes? In the course of every ordinary day, we inhale the droplets of deaths that our culture carelessly causes, and is this another way the sickness spreads?

A junco strikes the window, hard, but flies away to shelter under the salal bush. I don't know how badly he is hurt. The impact left a tiny

grey feather stuck to the glass. The storm winds lift the feather, as if it would fly away alone.

We can harden ourselves against others' pain and plans, defend our hearts from breaking, by constructing walls that block our ability to see the humanity of our neighbors and the animacy of the planet. But how can a heart so tightly constricted continue to beat? Could it be true, what the drawing suggests, that maybe what is killing us is that our hearts are not yet broken?

# 15 welcome transformation

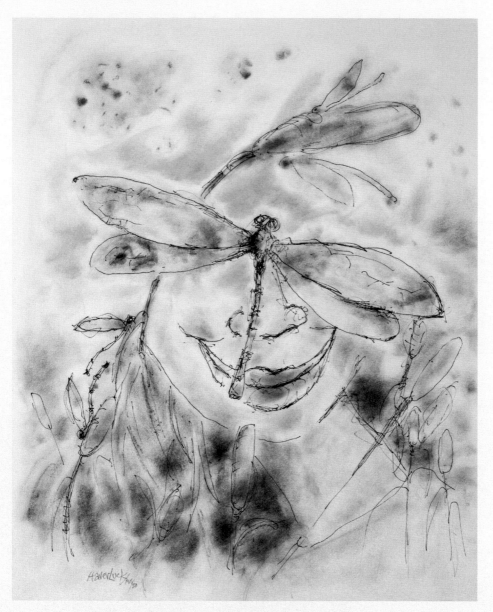

*Warning: Do not go to places of green cedar or red willow,
cattails—'cause chances are you will be mugged, robbed of your coat
of knowing, your pants of having. But . . . you may be robed with
wonder and what you see, saw you in two with a remembering that
can turn your winter heart into spring.*

# the sizzle down the spine

My kayak's name is Professor Plum. The lake's name is Crane Prairie. The little stream entering the lake just here is Quinn Creek. The weather is sunny, with a delicate wind from the west. The water plants that slow my paddle are tules, slender green bullrushes that grow in shallow water, abundant as bristles on a brush. The mountain to the north is a snow-patched volcanic core in the Oregon Cascades called Broken Top. I'm going to have to look up the scientific name of the blue insects that are flying everywhere; I've always called them blue damselflies, but I've heard blue dashers, vivid dancers, and tule bluets, so I don't know.

The air is full of them. Blue damsels land on my baseball cap. They land on my nose. They land on the purple prow of my boat. They land on the paddle, then fly off when the paddle blade disappears underwater. I hold still to see how many damselflies will land on me. No counting. Dozens up and down my arms, dozens climbing up the kayak's chine, dozens on the curled bowline. It must be a record emergence of blue damselflies; the air over the tule bed is bedazzled with them. Here and there is a dragonfly—larger, with clear, veined wings. The air clacks and buzzes with blue bodies reflecting light from the lake.

The damsels are lovely little things with bodies like iridescent blue matchsticks. A compound eye bulges out on each side of their heads, so they can see forward, above, below, behind. On top of their heads, there are three more eyes that sense the light, and short antennae for

judging airspeed. Four long wings stretch out flat from the body, clear as crystal.

For many months, the damsel nymphs have been crawling around in murk and muck, peering shortsightedly through brown water shot through with gold. Bristled, ugly things to be honest, nymphs look more like drowned crickets than damsels. Brown as mud, they have a nasty toothed mouthpart that shoots out to capture tadpoles, scuds, and mosquito larvae. But at some point, the nymph has had enough of this aquatic life.

I lean over the gunwale to watch a nymph with bristled legs that has climbed up a reed into the light and firmly planted her feet. Her carapace splits up the back, and after a time, she climbs unsteadily out. Limp and weak, she stands with new claws on what had been her own back. It takes a long time for her body to pump fluid into her crumpled wings, but I have all afternoon to watch her. Finally, they expand to full glory—cellophane thin, spiderwebbed with red or blue veins, shimmering, iridescent, ready for flight. It's hard not to cheer when she lifts her wings and flies away.

The adult damselflies don't live long—a week, maybe—and all week long, they make love. I can see countless damselflies in mating pairs, flying around attached, his head to her tail, his tail to her head, so their joined bodies make the outline of a valentine. Who would think of a winged valentine? But this reproductive strategy has worked for three hundred million years. Long before there were dinosaurs, there were giant dragonflies, two feet across, chewing with serrated teeth and squirting sperm like aerial refueling tankers.

The rays of the falling sun, shooting between black mountain crags, strike sparks off a zillion quivering wings. The mountains turn black as the sun sets and the lake melts into gold. All around, large-mouth bass and rainbow trout slurp up the floating bodies of damselflies, sucking

holes in the surface of the lake. Above the crimson streaks of sunset, a new moon appears. Then trout are leaping into the air and catching the damselflies on the wing. The splashes they make, returning, flutter like flame. The evening is astonishing and utterly improbable. How can this be, that I am floating here on a blue planet that is plunging through the darkness of the cosmos, floating here along with all the glittering damselflies and the ones just crawling out of their skins? I grab a handful of tule reeds and hang on.

Is this what it feels like to crack open—this sizzle down the spine? Is this what it feels like to be suddenly released from shriveled short-sightedness into ancient, ongoing spirals of lives and galaxies? To be suddenly sprung from a shrunken sense of options into a world of infinite possibility? Can humans too flex their backs and slide out into gladness that cannot be contained? Can we live in bright, trembling gratitude? Let us climb into a world we could never have imagined. Let us devote all our energy to continuing life. Let us be lifted by love.

# improvisational jazz

*Jazz is the ability to take the "hardest realities of life and put them into music, only to come out with some new hope or sense of triumph."*
— MARTIN LUTHER KING JR.

"We are all members of a great human orchestra, and it is now time to play the *Save the World* symphony. You don't have to play a solo, but you have to know the instrument you hold and find your place in the score." With this rousing metaphor, the climate activist ended her call to action and stepped away from the microphone. A great murmur and shuffle, and a couple hundred people rose to their feet, clapping.

*Damn,* I thought. *That's a GREAT metaphor. I wish I'd thought it up.*

It's true. Each of us holds an instrument—social media skills or a powerful speaking voice or spare money or the ability to lick a stamp. And yes, each of us has a part to play in the last-ditch scramble to prevent climate catastrophe. How exciting it will be when the conductor hands out the musical scores, taps her baton on the podium and, on the downbeat, we begin to rehearse.

But I hadn't walked two blocks toward home when I stopped cold. *Like, WAIT A MINUTE. If this is a symphony, where's the score? How can I get my hands on a copy? Do we even have time to rehearse?* And then I was as frustrated as I've ever been. *I would LOVE to play this symphony.* I would be nervous, of course, afraid I would hit a wrong note or blat out in the wrong place, but think of the power of this sound, all of us playing together. And I know other concerned citizens are hungry for

the chance to play in any *Save the World* orchestra. "Just tell me what to do," they beg in the Q and A, "and I will do it."

But. Here's the problem with that symphony: it doesn't exist. And nobody's going to compose it.

I turned the corner and walked toward home, dodging traffic that was leaving the auditorium. The predicted rain had come, a storm of tiny meteors in the headlights.

This isn't a symphony we have to play. This is all-out improvisational jazz, with its risk and surprise and its power to shake the air. No score, no practice sessions, no going back to try it again. Everything depends on our skill at real-time composing. We are going to have to make it up as we go along. If we are going to Save the World, it will be with the greatest exercise of improvisational imagination the planet has ever seen. The great jazz trumpeter Wynton Marsalis said it. "It's creative process incarnate. If you can't improvise, you are going to be in a heap of trouble."

So how the heck are we going to pull this off?

A week later, I was sitting under a huge oak with John Bliss, who was wearing a porkpie hat and holding a guitar. John is an extraordinary improvisational jazz musician who, by some wonderful circumstance, happens to be my friend. I opened the notebook on my knee and cocked my ballpoint pen. "Okay, John," I said. "What are the rules of improvisation?"

He looked at me, ready to laugh. "Three rules," he said, "according to Miles Davis. One, learn to play your instrument. Two, listen hard to the music being played around you. Three, forget all that shit and blow."

Then John did laugh, bending over his guitar. Lots of ways this miracle happens, he explained, but here's one: somebody starts. That

musician lays down an idea, a melody, a statement of the theme, plays it straight through, a few notes, whatever they've got. Then somebody else responds, changes the rhythm or plays the mirror reflection, complicates it. "Don't cover too much territory, but *make something* of the line of song." Then somebody else. Then a couple people respond to that. "Nothing is so exhilarating as when a group improvises together and it really happens. When it's all over, you look at each other and say, how did that happen? But it did. You made something."

Got it. So. Let's work this metaphor, people.

"Rule One. Learn to play your instrument." I don't think we need to sneak out to jazz clubs and hang out with the musicians all night. But we need to figure out what we are good at, and then we need to get better, and maybe that does mean apprenticing ourselves to a virtuoso or joining a workshop, I don't know. But it certainly means practicing. Practicing means doing it, then doing it again, better. And again.

"Rule Two. Listen hard to the music around you." If improvisation is variation on a theme, or call and response, whatever, then you have to hear the call. Listen to the voices of all the instruments, not only the loudest or most insistent—the shouting radio voice, the purple-faced panelist. Listen for the voices you do not hear; they may have the most to say. Listen to the Swedish teenager at the microphone: "I'm doing this because you adults are shitting on my future." Riff on that. Listen to the woman mounted on a white horse: "Standing up for what I believe in, not just sitting back and letting people do the wrong thing." Mirror that. Listen to the people walking from a church, holding hands and singing: "The truth shall make us free someday." Respond to that. Listen to the wind tear a roof off a shed. Then you will know how to respond.

John grinned. "The thing is, you can't make a mistake. Miles Davis said that too. 'There are no wrong notes. There are only opportunities.'

Whatever you play, someone else will make something of it. The important thing is to add something. An off note might shatter the surface of the music, but maybe that's what has to happen. Throw some sand into it. Think of how climate activism changed overnight to climate JUSTICE action." John picked up his guitar, played a bit of Bach, then an unexpected note, and he was off into something newly imagined, a thread that he spun as it unspooled.

Then Miles Davis's third rule: "Forget all that shit and blow." I think this is what we are going to have to do, if we are going to face down climate chaos. Let a thousand improvisations sound out, maybe a million, all these threads to the future. Not a single *Save the World Symphony*, but heaps of climate action playing in the rain, in the mud, in the corporate headquarters, in the streets, all around the world—everybody making it up as they go along. This is the way we will make the future.

This isn't about those "Fifty Things You Can Do to Save the World" lists. Those are distractions often written by shills of the fossil-fuel industry, eager to accomplish the final transformation of human beings into consumers (buy LED lightbulbs, switch to natural gas) and trick us into blaming ourselves, mistaking ourselves for the real villains, while they drive the bus headlong toward the Cliff-of-No-Return.

Instead, let's riff on, respond to, elaborate on the lead notes of the most brazen of the new ideas. Stop the construction of any new fossil-fuel infrastructure. Pipelines, compressor stations, refineries, new fracking wells—too late for those. Plant and protect forests and shorelines and anything else that will sequester carbon. Rebuild the soil and protect the water, even as they grow food. Reimagine cities built on principles of justice, and honor sacred land. Decarbonize the construction industry. Strip away the social license and financial support of Big

Oil by exposing their massive violation of human rights. All of these at once, and more.

John turned thoughtful. "I'm not sure. It's not really about agendas," he said. "Like, in Brazilian jazz, it's about values. The first value is awareness—listening, as Miles Davis said. What is happening around me? What are the others doing with their instruments? Who is too loud, and whose voice can I elevate? This is the most intense listening you will ever do."

Again, his fingers plucked music from the air and spun it into something that rose like a kite string.

"The second value is adaptability and responsiveness. You have to be quick to respond to change. There is no leader you can count on; there are no sidemen, following the leader. This is democracy, performing without a net."

"Terrifying," I said, but John quickly corrected himself. "No. There is a net. It is the other people in your band who will make something of what you offer them, no matter what it is."

"What's the third value?"

"Generosity. You share the airtime. You share encouragement and support. You celebrate what you make together."

"Watching you perform, John, I think there's another value," I said.

"What?" John set his guitar in its stand.

"Courage. Whatever happens, you have to make it work. You have to."

"Courage and perseverance," he said. "I think that's right. Even if your band has a shipwreck, you keep on swimming and you will find something that floats."

Ha. Another metaphor. But we will leave that one for another day.

# 16 practice gratitude

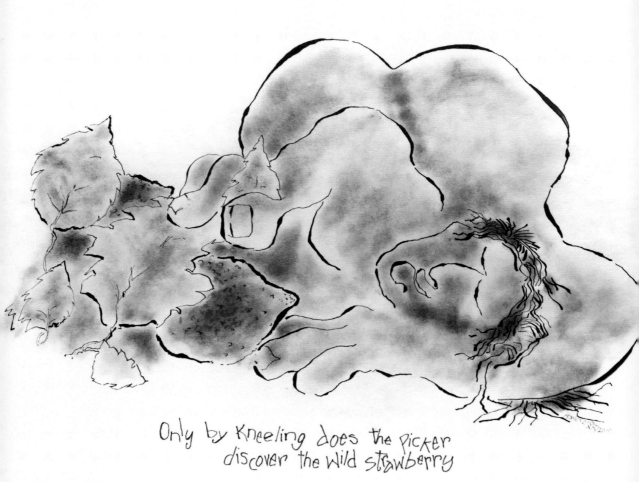

Only by kneeling does the picker
discover the wild strawberry

# the potato and the fog

My friend Hank once spent a week with a Buddhist monk, tenting on the outer shores of Chichagof Island, where North Pacific storms lash the cliffs and where, when the sun breaks through, the strand and the sea and the gulls and the beach grass all shine the same silver. Hank is a lanky Alaskan who lives with his wife and daughter in a hand-built cabin next to a big garden. Potatoes, peas, rutabagas grow irrepressibly from the heaps of nourishing seaweed that Hank pitchforks from the beach.

As Hank and the monk walked the tide line, the monk told him that everything we notice, everything we think, all the feelings we accumulate don't just disappear when we get done with them. They lie submerged below the surface of our lives—anger, gratitude, beer advertisements, pride, gladness, the smell of the woodshed, dreams of revenge, the sour taste of shame. They bubble up at times we can't control, nourishing or nasty. So be careful about what you store up, he said. Don't collect the bad stuff, and don't let anybody else leave their trash with you either. Let it flow on through, in one door, out the other, like a scouring tide.

But how do you keep the bad stuff from lodging in every corner of your brain? I asked Hank. Pay attention to the present moment, he said. Every moment we are wondering at the path of wind across the water or smiling to see a dog rest in the sun, we are not rehearsing our misfortunes. Breathe: sea-wind, kelp-brine, cold. Notice: fireweed, otter track, foxglove, fog, a face in firelight. Every moment we are glad for

the twilight of morning, we are not vexed. It is impossible for a heart to hold gratitude and sorrow at the same time.

I was so surprised by what he said. I thought about it long and hard.

My friend Robin says a prayer of thanksgiving every morning and at the beginning of every meeting. *As is the custom in my culture and in many others, let us begin with gratitude, for we are showered daily with the gifts of Mother Earth—food to eat, sweet air to breathe, and the preciousness of water. Gratitude for each other as people, for the privilege of our shared work.*

When I hear my friend pray, I am embarrassed by the prayer I said every night of my childhood. With folded hands, I knelt by my bed and said—as quickly as possible, because it was cold there, bare-legged on the hardwood floor. *God bless mommy and daddy and Nancy and Sally and Pixie the Dog, and make Kathy a good girl, Amen.* Never did I say, thank you for a good-enough dog and for parents who love me and sisters who tolerate my existence. Never did I say, thank you for not making me more wicked than I already am. I was too busy asking for more blessings, to say thank you for the ample blessings I had already received. Always asking for more. Now, when my friends call me to gratitude and tutor me in the ways of thanksgiving, they are offering me a transforming gift.

For a month one autumn, I lived in a cabin near Hank's. He told me that if I am to live close to the wilderness, I will need to live the grateful way and accept its gifts. He, Anya, his wife, and Linnea, his tiny daughter, often brought me food. There was venison pizza and a jar of wild strawberry jam. Smoked salmon on pasta. A bowl of highbush cranberries. Homemade bread. Finally, I said, "I can't accept any more of these beautiful gifts. I have no way to repay you."

Hank addressed me quite sternly. "Then you will have to learn to accept gifts," he said, "and a good way to learn is to practice."

I practiced that evening, receiving a drawing of a cabin with a spiral of smoke above its chimney and a russet potato dug fresh from the ground, both from little Linnea in a red dress. I practiced that night on the scent of sea fog as the tide sidled up the salt creek. When rain awakened me, there was the weft and warp of willow leaves on the window.

And now this moonlight in a trembling path across the water.

The Earth offers gift after gift—life and the living of it, light and the return of it, the growing things, the roaring things, fire and dreams, falling water and the wisdom of friends, forgiveness. Yes, the gift of forgiveness—time, and the scouring tides. How does one accept gifts as great as these and hold the gifts in the mind?

Failing to notice a gift dishonors it and deflects the love of the giver. That's what's wrong with living a careless life, storing up sorrow, waking up resentful, walking unaware. But to turn the gift in your hands, to say, this is wonderful and beautiful, this is a great gift—these honor the gift and the giver of it. Maybe that is what Hank has been trying to make me understand: notice the gift. Be astonished at it. Be glad for it, care about it. Keep it in mind. That kind of gratitude is the greatest gift a person can give in return.

"Gratitude is our work," writer Brian Doyle told me shortly before he died, "which is work of substance and prayer and mad attentiveness, which is the real deal, which is why we are here."

# 17 be earth's ally

See this, the viewpoint demands. You may not turn your eyes away. These birds, these beings, these small lives that cannot keep from singing?—these stand in the way of the terminus of a planned 280-mile natural gas pipeline. A $10 billion project, it's designed to bring fracked gas from Canada and the Rockies to a shiny new export terminal, where the liquid will be re-gasified and exported to Asia. Just across the shoreland, the morning sun shines on pink flagging that marks the course of the pipeline. Blueprints detail a huge tank of explosive gas to be built on dredging spoil a few miles downriver. The project bulges with inconceivable amounts of cash, federal government subsidies, a fleet of white F-350 diesel trucks, abundant lies, and the threat of Oregon's largest greenhouse gases emissions ever.

See these birds. See their glory and the sins plotted against them. *Nature thunders to man the laws of right and wrong*, Ralph Waldo Emerson wrote. It is right when a marsh at daybreak shimmers and sings; that is as it should be. Whatever destroys its joy, its beauty, the ancient urgency of its lives—that is wrong.

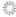

But the birds don't stand alone. Another tide is rising. It's a swelling affirmation of the worth of this coastal shoreland—not as a dumping ground for dredging spoils, but as an ancient community of slippery, shining lives. Not as a promise of temporary and poorly paying jobs, but as a vision of lasting livelihoods based on a thriving ecological and cultural community. The people stand with the birds and the salmon. They stand with what is lasting and life-graced.

The pipeline company doesn't have to speak, to reveal its threats. *We will stage public hearings in which only company representatives can be heard. We will spend fifty times as much as you can raise, to defeat a ballot measure against us. We will seize your land to serve the "public purpose" of bulldozing*

*a ninety-five-foot wide clear-cut for the passage of the pipeline. We will dredge the shipping canal and pile tailings the equivalent of twenty-seven football fields one hundred feet high. We will, of course, not harm clams, spawning salmon, the livelihoods of fishing families, the schoolchildren watching as ships loaded with thirty-nine million gallons of explosive gas pass by, or the sixteen thousand people living in the hazardous blast zone.*

A flock of crows flaps in low over the newly exposed tideflats. They hop to a landing, settle their shimmering wings, and begin to mutter among themselves. People—Jody, Sandy, Thomas, Allie, Don, Stacey, Hannah, and scores more—pick up their phones, also muttering as the tide reaches its lowest point and stalls.

"My husband and I have lived on our ranch for the past twenty-nine years," Sandy says, "working extremely hard to create and live our dream. For fifteen of those years, we have been fighting the proposed gas line." The pipeline company has plans for Sandy's pasture: a gravel parking lot for company trucks, bulldozed into the hillside and surrounded by chain-link fence. As for the stream where Sandy has painstakingly recreated a salmon run, the industry will dam it, rip out its vegetative cover, dig a trench for the pipeline, and then "restore" the salmon.

At this time of year, migrating flocks of sandpipers, dowitchers, stilts —the delicate, twitching shorebirds—scurry across the flats on little legs, pulling shrimp and worms from the sand. Many people also are on the move.

Some make phone calls to officials. Some paint dead salmon on parade signs. Some set up a website. Some begin organizations: Southern Oregon Rising Tide. Some write letters. Some raise money for lawyers. Some testify at hearings, citing international hazard experts. Some work to create new tourism and renewable energy jobs. Some document the larval crabs and salmon fry in the eelgrass. Some create alliances—tribes, nonprofit environmental justice organizations, parents,

fisherfolk. Some carry petitions door to door. Some come to the edge of the water to sing and pray; there is no hushing them. Some might pull out the surveyor's stakes, but this is not widely known.

Look: two hundred people are lined up on the Oregon State Capitol steps, here to talk to the governor. One hundred state troopers stand beside them, hands on their belts, waiting too. The people carry hand-painted signs and cell phones. The police have two-way radios attached to their shoulders. They punch buttons and lean over to talk out the sides of their mouths. Finally, half the people walk peacefully into the public space of the governor's reception hall. They sit on the floor to wait. Somebody calls out for pizza. They sing and will not be hushed: *Like my great-granddaughter watching over me.* Eight hours later, the governor stops by to say that she will not take a position on the pipeline and terminal; she will wait for the official approval process to play out. Troopers move in to arrest twenty-one people. Sandy is one of them.

By now, the struggle over the terminal is national news. Reporters bear witness to the damage the terminal will do to the estuary, to the town, to the global future. The slack tide gathers itself and begins to rise. Over the years, state and federal agencies, one after another, have denied permits for the project. Now, citing "external obstacles," the pipeline company announces it will not move forward with its plans.

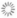

The tide turns. It really does: when things are at their lowest point—that's exactly when the tide turns. Water rises in the tracks of the deer and bubbles up the tunnels left by the siphons of crabs. Pushing lips of foam, rising water fills the depressions where ducks had dabbled for periwinkles. An egret lifts one foot, another, then spreads magnificent white wings and flaps away. The eelgrass turns with the tide, pointing now upstream. The tide carries what it finds: dry beach grass, a crow's feather, a scrap of pink flagging.

# 18  defend the children

# the mother, who was a bear

"Bear." That's what you say in Alaska when you see a brown bear trundling toward you down the beach. Your impulse will be to yell "Run!" But that's a bad idea. This bear was mid-sized, maybe five hundred pounds, brown with a golden saddle. Not running exactly, but the bear wasn't wasting any time either, and the distance between us was closing at a speed that struck me as alarming. Trucking along behind her was a yearling cub. The little guy was having trouble keeping up. He stumbled along, whining.

We had been throwing fishing lures at the mouth of a stream, hoping for trout or even a salmon. It was bear country, Glacier Bay, Alaska, so we weren't surprised to see a bear. But we were surprised that she was heading for us, rather than away. After all, we had been making lots of noise to alert any possible bears, and there were five of us and an aluminum skiff pulled up on the bank. That's a formidable gathering, and we would have expected a mother bear to slip silently into the brush and disappear.

"Yep, bear," I said, as I sidled behind the skiff.

"I don't get this," muttered my husband. "She knows we're here."

The bears continued to make a beeline toward us, clambering over a log next to a willow swale, splashing through a tidepool. Every so often, the sow glanced over her shoulder into the alder forest on the hill that rimmed the beach. When we followed her glance, we saw what she was running from. A line of wolves was stalking her, maybe five of them, fifty feet or so up the hillside. They darted in and out of the trees to

keep her in sight, never faster than the bear, but never slower, making no sound at all. Ravens were yelling by now, and we could hear the bears' paws crunch gravel.

When she came to the edge of the stream just across from us, the sow stopped and lowered her great head, swinging it back and forth. Then she waded into the water, herding the cub ahead of her. As I say, it was a narrow stream, maybe thirty feet across, with a deep pool in the center. That's where the sow and the cub stopped to . . . to do what looked a lot like play.  Floating as upright as if she had been wearing an inner tube around her belly, the sow reached over and dunked the cub. He sputtered and grabbed for her shoulder. She swatted him under again. They hugged and rolled. We stood frozen on the bank, watching the bears goof around. In the penumbra of our power, they were safe from the wolves, and they knew it. The wolves melted into the forest. We did not see them again.

After a time, the bears shambled up the streambed to a sandbar, where the sow grazed on sedges and the cub napped. When we looked again, they were gone.

I sat down on the beach. For a long time, I just sifted sand through my fingers and tried not to cry. I confess it: I had been scared half to death, and now that the danger had padded away, it was hard to keep back the tears. I am born of a mother who was ferocious in her daughters' defense. She would stand courageously against anything that threatened us—a feckless school principal, a nest of wasps, a perverted Methodist minister, even once a rabid skunk. And always, when the danger was over and she stood tall, holding our hands, there were tears streaming down her face. Maybe men laugh when they avert a danger; maybe women cry. Maybe mother bears play.

I am the mother of two children. When my children were babies, I cradled them in my arms and whispered a promise into their seashell

ears. *I will keep you safe.* Isn't this what all mothers do? But our children are not safe, as the relentless, destructive expansion of the human presence breaks down the planet's life-sustaining systems. Several years ago, five hundred scientists, led by a team from Stanford University, warned the world: "Unless all nations take immediate action, by the time today's children are middle-aged, the life-support systems of the planet will be irretrievably damaged."

A damaged planet will not nourish the little ones—let's not deceive ourselves. I promised the children a healthy world that would provide them a healthy life, not a poisoned, bulldozed, desperate world, where forests burned and rivers ran dry. Not an insane world, where powerful people pursued profit, even to the end of civilization.

I made the promises, and I have to be the promise-keeper. But honestly, I don't know if I can do it. I don't think I can be as courageous and cunning as the bear, with powers honed, sharpened, and passed down to daughters over generations. But I would be glad if I could be as stubborn and ferocious as my own mother, who loved me and protected me and taught me to stand up for what I care for more than anything else in the world.

# 19　set a strong example

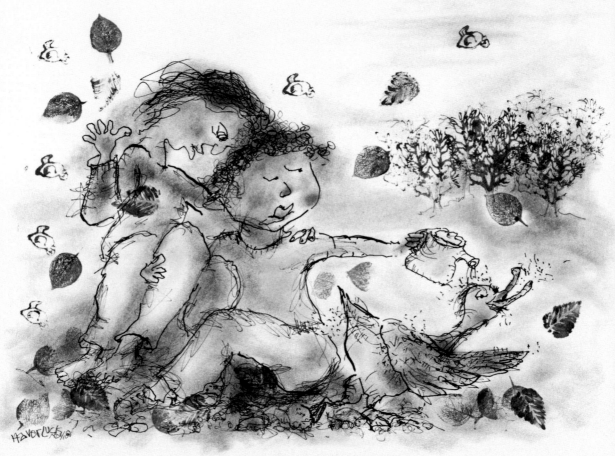

Children asked their Parents, "Why are the grown ups
cutting down the forests, making rivers and oceans
sick, letting the song birds die?"
    The Parents answered, "Let's talk about a new T.V.
for your bedroom and a family trip to Disneyland."
    And the children whispered to one another,
"It frightens Dad, scares Mom when we talk
about what's scarey. Best we keep our fears
to ourselves."
    And so the children did, and do.

# the world depends on this

The message machine was blinking when I got home from work: "I want you to know that your daughter is going to be fine." I braced myself for whatever would come next. "She was arrested during the demonstrations. They're holding her in the San Francisco County Jail."

I tried to picture a jail at night. Do the other inmates sleep splay-legged and heavy on their backs? Do they curl up as if they were babies? And our daughter?—surely she's sitting awake on a bench with her knees to her chest and her arms wrapped around them. She will be cold, in that dark place.

Babies startle if they are not wrapped tightly. We learned this in a childcare class before she was born. Their bodies twitch and their arms flail as they sleep, and if nothing is holding them, they are afraid. So you have to wrap a newborn baby. We held our daughter close and wrapped her in blankets, tight as corn in the husk. We loved her so much and raised her so carefully, and isn't this what all parents do if they can? It never occurred to us that she would go to jail.

So here is the first thing she said when she called collect from the holding cell: "What can I say to keep you from worrying?"

To keep a parent from worrying?

"Tell us you're home in bed," I shouted, but my husband took the phone from my hand. She told him she was in a holding cell with dozens of other women. They are strong, amazing women, many of them mothers and grandmothers, she said, and Frank thought that our

daughter's own voice was strong and amazing, more certain than he had ever heard.

The police released her at 2:30 a.m. A friend came into the city to drive her home.

Don't all parents want the world for their children? *Fellow parents, tell me, wouldn't we do anything for them?* To give them big houses, we will cut ancient forests. To give them perfect fruit, we will poison their food with pesticides. To give them a ride to school, we will leak bunker oil in the last wild places. To give them the best education, we will invest in universities that profit from death. We go busily about, buying this or that, voting or not, burning up gasoline or jet fuel or split pine— on a small scale, in the short-term, making things work for our children—forgetting that whatever is left of the world is the place where they will have to live.

What will our grandchildren say? I think I can guess:

*How could you not have known? What more evidence did you need that your lives, your comfortable lives, would do so much damage to ours? Didn't you wonder what we would drink, once you had poisoned the aquifers? Didn't you wonder what we would breathe, once you poisoned the air? Did you stop to ask how we would be safe, when even the weather turned against us?*

*You, who loved your children, did you think we could live without clean air and healthy cities? You, who loved the Earth, did you think we could live without birdsong and swaying trees?*

*And if you knew, how could you not care? What could matter more to you than your children, and their babies? How could a parent destroy what is life-giving and astonishing in her child's world? And if you knew, and if you cared, how could you not act? What excuses did you make? And now, what would you have us do?*

Two days after she got out of jail, our daughter walked with us beside the ocean. Under a steep headland, we came across a jumbled heap of

fishing nets, nylon cord, and bullwhip kelp, intricately tangled. Buoys were smashed and buried beyond hope.

"This is what the world is," she said. She tugged at a rope in nets gone to tangled ruin, drifted with sand.

"Maybe. But you don't have to go to jail to say so. There are other ways," I said softly, knowing I should be still.

She answered as softly. "Then you need to show me those ways," she said. "Don't tell me. Show me."

Dear God. I don't know what to do: what to hope and what to fear, what to invest in and what to give up, what to insist on and what to refuse, how to go on with living in a time of danger. All I know is how to hold my daughter, wrapping my arms tight around her shoulders. Right now, the world depends on this.

# 20 open yourself to deep change

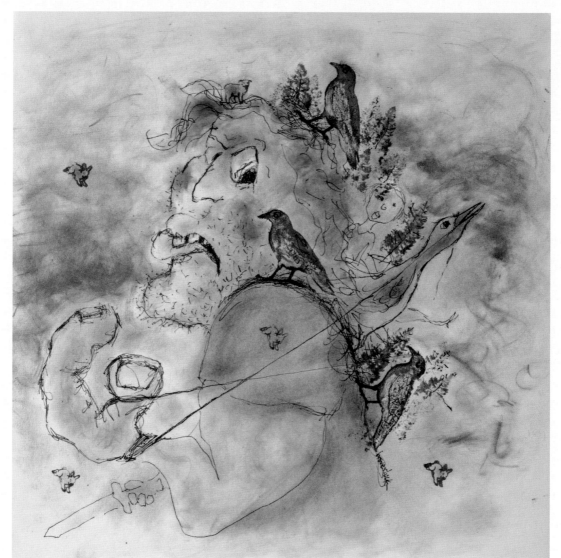

As Macbeth Prepares to Murder, trembling he
hesitates before the troubling bodies of kings, children,
trees, horses... nature's body to which he knows he is
tied, treaty'd. So he Prays, "O come night, cover the tender eye
of day. And with thy bloody & invisible hand— cancel & tear to
Pieces the great Bond which makes me timid".

# with the wisdom of a volcano

Over the years, college students have often come to my office distraught, unable to think of what they might be able to do to stop the terrible losses caused by an industrial growth economy run amok. So much dying, so much destruction. I tell them about Mount St. Helens, the volcano that blasted a hole in the Earth in 1980, only two decades before they were born.

Those scientists were so wrong back in 1980, I tell my students. When they first climbed from the helicopters, holding handkerchiefs over their faces to filter ash from the Mount St. Helens eruption, they did not think they would live long enough to see life restored to the blast zone. Every tree was stripped grey, every ridgeline buried in cinders, every stream clogged with toppled trees and ash. *If anything would grow here again,* they thought, *its spore and seed would have to drift in from the edges of the devastation, long dry miles across a plain of cinders and ash.* The scientists could imagine that—spiders on silk parachutes drifting over the rubble plain, a single samara spinning into the shade of a pumice stone. It was harder to imagine the time required for flourishing to return to the mountain—all the dusty centuries.

But here they are today: on the mountain only forty years later, these same scientists are on their knees, running their hands over beds of moss below lupine in lavish purple bloom. Tracks of mice and fox wander along a stream, and here, beside a ten-foot silver fir, a coyote's twisted scat grows mushrooms. What the scientists know now, but didn't understand then, is that when the mountain blasted ash and

rock across the landscape, the devastation passed over some small places hidden in the lee of rocks and trees. Here, a bed of moss and deer fern under a rotting log. There, under a boulder, a patch of pearly everlasting and the tunnel to a vole's musty nest. Between stones in a buried stream, a slick of algae and clustered dragonfly larvae. *Refugia*, these sites are called: places of safety where life endures. From the refugia, mice and toads emerged blinking onto the blasted plain. Grasses spread; strawberries sent out runners. From a thousand, ten thousand, or maybe countless small places of enduring life, forests and meadows returned to the mountain.

I have seen this happen. I have wandered the edge of Mount St. Helens's vernal pools with ecologists brought to unscientific tears by the song of meadowlarks in this place.

My students have been taught, as they deserve to be, that the fossil-fueled industrial growth culture has brought the world to the edge of catastrophe. They don't have to "believe in" climate change to accept this claim. They understand the decimation of plant and animal species, the poisons, the growing deserts and spreading famine, the rising oceans and melting ice. If it's true that we can't destroy our habitats without destroying our lives, as Rachel Carson said, and if it's true that we are in the process of laying waste to the planet, then our ways of living will come to an end—some way or another, sooner or later, gradually or catastrophically—and some new way of life will begin. What are we supposed to do? What is there to hope for at the end of this time? Why bother trying to patch up the world while so many others seem intent on wrecking it?

These are terrifying questions for an old professor; thank god for the volcano's lesson. I tell them about the rotted stump that sheltered spider eggs, about a cupped cliff that saved a fern, about all the other

refugia that brought life back so quickly to the mountain. If destructive forces are building under our lives, then our work in this time and place, I tell them, is to create refugia of the imagination. *Refugia*, places where ideas are sheltered and encouraged to grow.

Even now, we can create small pockets of flourishing, and we can make ourselves into overhanging rock ledges to protect their life, so that the full measure of possibility can spread and reseed the world. Doesn't matter what it is, I tell my students; if it's generous to life, imagine it into existence. Create a bicycle cooperative, a seed-sharing community, a wildlife sanctuary on the hill below the church. Raise butterflies with children. Sing duets with the dying. Tear out the irrigation system and plant native grass. Imagine water pumps. Imagine a community garden in the Kmart parking lot. Study ancient corn. Teach someone to sew. Learn to cook with the full power of the sun at noon.

We don't have to start from scratch. We can restore pockets of flourishing lifeways that have been damaged over time. Breach a dam. Plant a riverbank. Stop a refinery. Vote for schools. Introduce the neighbors to one another's children. Celebrate the solstice. Slow a river course with a fallen log. Tell stories of Indigenous rights to lifeways and land. Clear grocery carts out of the stream.

Maybe most effective of all, we can protect refugia that already exist: they are all around us. Protect the marshy ditch behind the mall. Work to ban poisons from the edges of the road. Save the hedges in your neighborhood. Boycott what you don't believe in. Refuse to participate in what is wrong. There is hope in this—an attention that notices and celebrates thriving where it occurs; a conscience that refuses to destroy it.

From these sheltered pockets of moral imagining, and from the protected pockets of flourishing, new ways of living will spread across the

land, across the salt plains and beetle-killed forests. Here is how life will start anew. Not from the edges over centuries of invasion; rather, from small pockets of good work, shaped by an understanding that all life is interdependent, and driven by the one gift humans have that belongs to no other: practical imagination—the ability to imagine that things can be different from what they are now.

# 21  choose one issue and give it all you've got

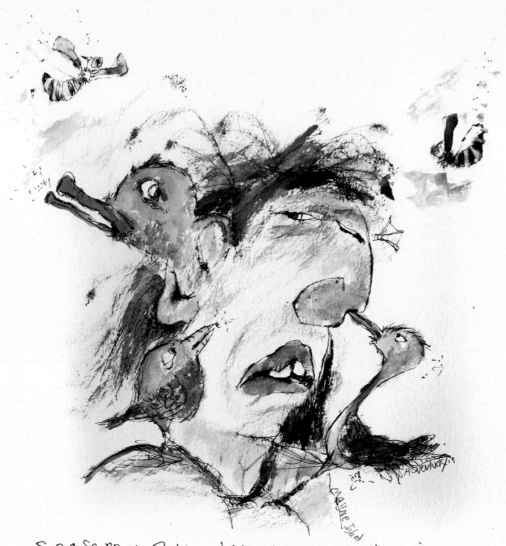

Song Sparrows, Ducks, Wetlands, Soil made sick are saying, "Listen, its time for you to be showing your love for the wounded Earth!

If you got no love, then show Some respect!

If you got no respect, then at least show enlightened self interest. Because even if your heart and mind aren't here with the damaged watery earth, your ass is!"

# it is enough

Racist policing. Oil spills. Destruction of wild habitats. The list of the world's wounds is long and tragic. Lead poisoning in water. Dead zones in the ocean. Brutal borders. Floods in Bangladesh. Corporate logging. Sick schools. Tundra wildfires. Cancer-causing chemicals. Pandemics powered by poverty. That's an even dozen, but I'm only getting started. The problems are so many, they fly at us so fast, it becomes impossible to respond. The temptation is to shrug. How do you even start to clean up such an epic mess?

My colleague, who teaches animal behavior at our university, illustrates the problem by throwing a tennis ball at a student in the lecture hall. She neatly grabs it out of the air, stands up, and takes a bow. Then, all at once, he throws five balls at the student. She can't catch a single one, and neither can any of the students sitting next to her. The multiplicity of balls confuses and overwhelms them. So it is with Earth's weary lovers.

Starlings know the confusing power of the multitudinous, gathering in flocks of thousands to confound predators.

Shoaling fish know this.

Swarming insects know it.

Herds of wildebeest know this, and the lions know from hard, hungry experience.

Coots know this. Just this summer, I watched a flock of coots use the strategy to escape a bald eagle hunting over a mountain lake. Looking for lunch, the eagle veered low and hard over a flock of maybe a hundred coots. Every coot clawed across the water, tearing it to shreds,

and ran simultaneously into the air. The ruckus—the splashing water and flopping wings and honking cries—foiled the eagle entirely. He flapped disconsolately through the mob and flew back to his spar.

Even ex-President Trump understood, throwing out dozens of incoherent and menacing tweets every day, leaving dismayed opponents grasping at air as the next tweet hit them on the side of the head.

What is a concerned and conscientious person to do, when urgent issues come so fast, from all directions? The natural reaction is to duck and cover. The natural reaction is to despair. But the natural reaction is disastrous, when there is so much essential work to be done and the world needs every one of us in the struggle.

When my students ask how to find their calling in the middle of the onslaught, I offer the words of eco-philosopher Joanna Macy: *You don't have to do everything. Do what calls your heart; effective action comes from love. It is unstoppable, and it is enough.*

I think that is right in every particular, in every sentence:

*You don't have to do everything.* The planet's problems are knotted together in causal tangles that might make us tear our hair out. But this is a good thing; it means that an intervention at any single point will have an effect on the whole mess. You just have to do your part, trusting others to do theirs. And you don't have to do it alone. When you choose your cause, you will find your community. When you find your community, you will find your role.

*Do what calls your heart.* What do you love more than anything? I ask my students. What could you never give up? "Surfing," says one. Then you are a defender of the oceans, I say. "Hip-hop," says another. Then you are a voice of justice, a witness to wrongs, a beacon of a better way. "Beer," says another (of course). Then you are a protector of barley and hops from agricultural poisons, and by that means, a protector of the rivers and all their glistening lives. "My girlfriend," says another. Then you are a warrior

for women, standing against rape and murder and the invisible violence women face every day. And then a student says, "More than anything else, I love my little daughter." I move close to the student and touch her shoulder, trying not to cry. Then you are a climate activist, I say.

*Effective action comes from love.* Hate and anger are heavy burdens. You can carry them if you think it makes you happy, I tell my students, but hate will steal your strength and sour your satisfactions. Lay that burden down. "Lean toward the whispers of your own heart," as John Lewis told us, and both you and your work will be transformed. You will be joyous in your work—eager, fierce, and courageous, as love tends to make us. Your actions will be authentic and compassionate, focused and joyous, and people will be moved to join you.

*It is unstoppable.* I ask my students: Can a mother stop loving her daughter? Can a farmer stop loving the soil? Can a young man stop loving a dream of justice? Can a thirsty runner stop loving the water, or a hungry child stop loving the corn? Never. Then no more can any living being stop loving the astonishing, nurturing Earth, no matter how broken it has become.

*It is enough.* If everyone chooses one cause and pursues it with all the power of their beating heart, imagine then all the "good trouble" that will fly into the faces of those who would wreck the world and plunder the future. From the front, from the side, from courtrooms, from parades, from voting booths, from newspapers, from school rooms, from NGOs—a hundred coots, six thousand starlings, one million schoolkids, one million social and environmental justice organizations, 4,686 Black Lives Matter protests and more every day, an entire fleet of kayaks blocking passage of an oil rig headed north. Imagine the confusion and consternation as the world-wreckers duck and howl against the onslaught. If everyone finds their good work for justice and eco-cultural thriving, it is enough.

# 22 never give up

Duck re-inflating a deflated activist

# why we won't quit   *Kathleen Dean Moore and SueEllen Campbell*

Last month, on the way from one meeting to another, my friend SueEllen Campbell and I stopped along the Oregon coast to camp for the night. We walked down to the beach to watch a red sun set through purple clouds. While parents gathered up their families, lingering children stood ankle-deep in pink water, looking out to sea.

We are old veterans of climate-change and extinction struggles who have tried to do our part to keep a fossil-fuel-addicted civilization from driving off a cliff and taking half the plants and animals with us. Are we tired? Sure. Discouraged? Absolutely. Pissed off? Yep. Sad? Call it broken-hearted. Quitting?

It might be time. *Game over*, friends and experts tell us. *We're doomed.* It's true that the news about the linked terrors of global warming, species extinction, and ecocultural collapse is awful. We all know the litany of accelerating danger. We all know we are running out of time.

"So why won't we quit?" SueEllen asked. "We need a list of reasons." We sat down on a log. This was going to be a conversation we would want to remember. I pulled out my journal to get it down.

"First," SueEllen said, "because we are *not* doomed, as long as we act. A world where we do everything we can to restrain climate change barely resembles one where we do nothing. We won't like the first world, but we might not survive in the second."

"Yes," I added, "and because I want to be the kind of person who doesn't give up on important jobs. You don't do what's right because you think it might get you something. You do it because it's right. That's

what integrity is—doing what you believe in, even if it won't save the world."

SueEllen paused for a long moment. "And because I won't walk away from the hurting world any more than I will walk away from my mother as she grows old and frail and sometimes confused," she said. "I love her and owe her and have a duty to her and admire her and enjoy her company."

"Yes, and because I promised my newborn children: *I will always love you. I will keep you safe. I will give you the world.* I didn't mean, I will give you whatever is left scattered and torn on the table after the great cosmic going-out-of-business sale. I said, *I will give you this beautiful, life-sustaining, bird-graced world.*" Truth be told, it just about kills me to think about the broken promises to the children. And when I think of my mother—if she learned that her daughter's generation was losing the battle for the beloved Earth's future, she would leap from her grave to fight alongside us.

"We have to do this work, because climate change is unjust. It threatens the greatest violation of human rights the world has ever seen. But injustice is cowardly and fragile; it crumbles when people stand up for what is right. We have so much to lose, and so much left to save—everything from birdsong to our own sorry souls."

"Yes," I agreed, and paused. I was surprised that I was crying. "Sometimes I think that I keep going because I am wearing my Dad's rubber boots. They are too big for me, but my own are old and leaky. So I am walking in the boots he wore at the edge of all the marshes he defended until the day he died. If you are walking in the shoes of a hero, you can't exactly turn back."

SueEllen waited to give my pen time to catch up. "And, Kathy," she said, "we can't and therefore don't have to solve the whole problem alone. We only have to help where and how we can. So many good

people are in this fight with us—in governments around the world, in businesses, in states and towns and neighborhoods and churches. They are smart and experienced and empowered by a vision of a planet redeemed. I believe, and choose to believe, that in this emergency, as in every emergency, more of us will come out to help each other than will rush in to exploit and profit."

"Yes. Exactly. We do this work because despair is lonely and useless, while climate action is full of friendship, satisfaction, and glee—you get to hang out with people who care as much as you do and act with remorseless resolve. Taking action is the only real cure for hopelessness. It feels good, and important, like you're not wasting your life on small things."

We stayed at the beach, mulling over our reasons to stay in the struggle, until the stars came out and the breeze came up. Then we walked back to camp on a mossy trail through a tunnel of spruce trees. A hermit thrush sang and would not stop singing, even in the deepest dusk, and that also was a reason. The deep moss was a reason. So were the ancient trees. So were the children standing in the swash.

*One tail-less, furless, not fearless bi-ped*
*(72% water, 2% coffee, 1% beer, 3% piss, 40% vinegar,*
*100% soil & soul). Learning to see differently.*
*Learning to hear differently. Learning to act differently*
*Learning the sorry dance. Also learning the*
*yet-to-be-announced dance of a healed Earth.*

# artist's note

In Jean Anouilh's 1959 play *Becket*, the victorious English King Henry looks over the defeated French city. He savors his army's might, confident that the army will make it simple to impose his will. But his counsellor Thomas Becket warns against making the citizens desperate with violence and intimidation. "Gentleness is better politics, it saps virility. A good occupational force must never crush. It must corrupt," advises Becket. Corrupting the citizens' imagination and understanding will confuse their ability to distinguish facts from poisonous fabrications. Such strategy requires fewer police in the streets, for the police will be in the citizens' heads, assuring a compliant populace. Then bribes and gentle threats will suffice.

In one of the Bible's books of political resistance literature, Daniel, the imperious King Nebuchadnezzar seeks to seal his divine-like status with a July Fourth of a celebration. All the people are gathered. The finest musicians of the land are there, playing such tunes that all, with tear in eye and hand on heart, sway and swoon. Then, awash with feelings of security and gratitude, all drop on their knees in worship of the king. But as the story goes, three citizens don't join the throng. They are soon arrested and put in a fiery furnace of a prison cell, left to cook and see their own foolishness. But it's their guards who are cooked by the flames, as they hear the three protestors happily hymning a counter-music, a protest song. Their resilient songs of a world without death-dealing machinations anticipates the music of the jail cells in

Selma and Birmingham, where "Keep Your Eyes on the Prize" and "We Shall Overcome" were sung out.

Perhaps the drawings and captions in this little book can help stir people to sing a protesting "No" and an affirming "Yes." Both in what the drawings say and how they say it, maybe they can help us see our corrupted desires and "unfold the folded lie." They can help us see our support of Big Oil for the bad deal it is. Help us see how, as we desperately try to avoid a broken heart, we may become party to breaking the heart of sister-mother-earth. And perhaps comic art can help us see the tragedy of not only believing too much, but of believing too little.

Drawings can alert us to the unhidden and unbidden goodness and delights that, in our urgency, we foolishly ignore. Me, I often forget that what allows us to oppose the Bad is the Good that we are given to rest and stand upon. When I got out of bed this very morning and stood on the ground, I did not remember that I was standing on "a great ball of fire wrapped in rock, watery earth, airy earth, watery air." I—surely not you—was not amazed. Not gobsmacked and grateful. Not on my knees or on dancing feet, singing hymns of hurrahs.

So I must draw these earthy, animally, tailed and tailless creatures so I won't forget. Because I am an ignorant biped. Not only ignorant, but fearful. Prone to dread. Not only of the Bad, but dread of the Good. There is so much goodness—too much goodness to be celebrated in gratitude. And being also lazy, I dread all the good to be defended and restored. And I also tend to recoil at the good I am called to live out.

No surprise, then, that I need the hard and soft pinches of tragical, comical art. And what is art but a form of play? Play is essential, especially when we are conned into believing that the game is utterly predetermined, fixed, stuck. "The situation is serious, so we must stop not playing," I wrote in *When God was Flesh and Wild*. "We need to discover

the play in things," the changeability of direction, the switches to re-route the trains—and ourselves. So the tragical, comical art joins the words of the essays, trusting they may help us all fool with the switches and address the malfunctions at the junctions.

Bob Haverluck

# gratitude

Many thanks to Liturgical Press for permission to use several drawings from the Haverluck collection of stories and drawings, *When God was Flesh and Wild: Stories in Defense of the Earth* (Collegeville, 2017). Thanks to the journal *Arts: The Arts in Religious and Theological Studies* 25:1, which first published two drawings along with the story, "The King of Bigger and More," in 2013. Several of the drawings were displayed as part of the performance of Haverluck's musical play, "The Court Case of the Creatures" at Trinity St. Paul's and Bloor Street United Churches in Toronto in 2017. With appreciation, they are used here.

Gratitude to publishers who allowed us to reprint all or parts of some of Kathleen's previously published essays. A version of "The Dawn Chorus" first appeared in "Dear America," a series published in the online magazine *Terrain.org*. The bear story in "Defend the Children" was first told in *Earth's Wild Music* (Counterpoint Press, 2021). A version of "The World Depends on This" was published in *Holdfast* (Oregon State University Press, 1999). "The Great Avulsion" is a much-revised version of "The Rules of the River," first published in *Great Tide Rising* (Counterpoint Press, 2016), where longer versions of "Pogo's Revenge" and "The Wisdom of Volcanoes" also appeared. "The Tide" is a much-expanded version of "The Tide (After Ralph Waldo Emerson)," which Moore and Erin Moore published in *Visualizing Nature*, edited by Stuart Kestelbaum (Princeton Architectural Press, 2021). "Why We Won't Quit the Climate Fight," coauthored with SueEllen Campbell,

first appeared in the online edition of *Earth Island Journal*. In every case, these little essays appear here through the goodwill of the publishers, for which we are most grateful.

A jumbo thanks to nature art photographer Sam Baardman, who spent hours galore retrieving Haverluck's ill-kept drawing photos and helping fashion them for this book. See www.sambaardman.com.

Erin Moore is the architect who designed and built "The Portal," the setting for "The Tide." Many thanks to her for sharing the pavilion and for her perspectives from this powerful place. See https://www.floatwork.com/portal-project-statement.

Deep gratitude to Frank Moore, Kathleen's beloved husband, who is a font of natural history stories, moral support, and grounded advice. Much thanks to Bob's poet partner Gerry Wolfram, who kindly consults on many captions, for her years of creative companionship, and to many friends across Canada whose support of the drawings and stories is ever heartening. Thank you, also, to Bob's reader counsellors, Hal Llewellyn, Lori Matties, Steve Willey, Paul Campbell, Donna Sinclair, Rhian Brynjoson, and Gerry Wolfram. Thanks to Gordon Grant and Fred Swanson for sharing their understanding of rivers, and to John Bliss, who taught Kathleen about jazz. Thanks to Kathleen's good friends for careful reading of essays and always helpful comments. They are John Calderazzo, SueEllen Campbell, Charles Goodrich, Carol Mason, Sally Swegan, Nancy Rosselli, Robert M. Rosselli, and Frank Moore.

And always, to the wrens and pine trees, the children and activists, the rivers, the doves, the bewildered ducks. For the ear-shot rabbits, and more ducks, for their dedication to life, we say thank you.